HOW TO UNDERSTAND AND USE
DESIGN AND LAYOUT

ALAN SWANN

HOW TO UNDERSTAND AND USE
DESIGN AND LAYOUT

A L A N S W A N N

NORTH LIGHT BOOKS

Cincinnati, Ohio

A QUARTO BOOK

Copyright 1987 Quarto Publishing plc
First published in the U.S.A. by
North Light Books, an imprint of
F & W Publications, Inc
1507 Dana Avenue
Cincinnati, Ohio 45207

ISBN 0-89134-212-5

Library of Congress Catalog Card No:

Swann, Alan, 1946–
How to understand and use design and layout

Includes Index.
1. Advertising layout and typography
2. Printing, practical layout.
3. Newsletters. I. Title
HF5825.S9 1987 659.13'24 87-13698
ISBN 0-89L34-212-5

·This book was designed and produced by
Quarto Publishing plc
The Old Brewery, 6 Blundell Street,
London N7 9BH

Senior Editor Lorraine Dickey
Art Editors Iona McGlashan, Gill Elsbury

Editors Lydia Darbyshire, Eleanor van Zandt
Assistant Editor Joanna Bradshaw

Designer Tony Paine
Picture Researcher Kate Duffy
Illustrators Mick Hill, Kevin Maddison
Photographers Rose Jones, Paul Forrester
Paste-up Patrizio Semproni

Art Director Moira Clinch
Editorial Director Carolyn King

Typeset by QV Typesetting Ltd
Manufactured in Hong Kong by
Regent Publishing Services Ltd
Printed by Leefung-Asco Printers Ltd, Hong Kong

Dedication
The author would like to thank
Patricia and Eva for their
patience and support during the
preparation of this book and
Paul Diner for his invaluable
assistance.

CONTENTS

INTRODUCTION

In this book I shall break down the elements that go into creating a piece of design. I believe the process of design, in its basic form, is accessible to anyone and everyone willing to spend some time studying and exploring each facet in close detail. The building blocks of design are the elements used in the construction and formulation of the final piece, and each has an identity and creative history of its own. The problem the designer faces is how to present his or her ideas and what combination of elements is needed to produce the most effective and individual concept for the piece of work.

WHAT IS DESIGN?

The function of a designer is to solve the problems of communicating products, concepts, images, and organizations in the most original and precise form. At its best, this is achieved through the collation of carefully chosen and arranged elements, the presentation of which is based on a formula that is essentially simple but that has been refined by the many stages through which it has developed.

In the pages that follow I shall attempt to develop your creative vision and judgment to enable you to distinguish between strong and weak methods of presenting design ideas. The first problems you will encounter are the realization and recognition of space and of the formulas that must be applied to the positioning of elements within this space.

The second section of the book will investigate the practical application of various design elements. You will also discover that some simple formulas may be applied to the problems of formal composition.

The third and final section will concentrate on the complete design process, and I shall investigate the stages of development that are implicit in achieving successful design solutions through a thorough and intensive progression of design procedures.

Finally, you should be aware of the increasing relevance of design as a part of the artistic and cultural development of the society in which we live. Design plays an important part in the way we project ourselves intellectually, spiritually and materially. Good design, communicating good services or products, is becoming a cornerstone of our society. In the past, companies concerned with quality and their own future development have invested conscientiously in the design and image of their products to establish themselves with future generations. It is the responsibility of all designers to attempt to make their designs relevant to the needs of today and effective for the years to come.

THE RIGHT APPROACH

Before producing any design work, the first consideration is to establish a detailed understanding of the task in hand. This is achieved by producing what is known as the design brief. Basically, all this means is that you collect every detail of inform-

ation concerning the nature of the subject for which you are providing the design. Investigate and question the client's requirements, making full use of his experience and knowledge of the subject.

Always bear in mind that the final proof of success will be determined by your client. You must also be prepared to produce many solutions to the design problem, even though you may feel that your first attempt conveys what you think is right and effective for the subject. The designer must be tenacious, persistent, and relentless in his or her willingness to experiment.

Finally, the presentation of all your designs must be to the standard that the client would hope his product or service demands. In other words, make sure that your standards are as high, if not higher, than those of the people for whom you are working.

STARTING WORK

A major consideration for the successful production of design work is a carefully planned and well-equipped working space.

First, you will need a reasonable desk and a comfortable chair to give good physical support. Next, you will need a surface to work on. This could be a drawing board or a tilted surface to allow you to work for long periods in a comfortable position. A drawing board can be propped up securely against a number of large books or blocks of wood. To provide adequate lighting you will need some form of desk lamp such as an Anglepoise to place over your work to allow you to view what you are doing at all times without creating shadows.

The materials and instruments you will need in the initial stages are well established in studio practice. Find for yourself a variety of right-angled triangles, a ruler and a compass. You will also need masking tape and Scotch tape, scissors and a good,

sharp, fine craft knife. Make sure that you have paste or glue for mounting and pasting up design elements. The instruments you will need for drawing and coloring include a selection of pencils of all grades, although you will probably use the softer ones more often, and a range of colored markers or pencils, both water- and spirit-based. Make sure you have some fine ones for detailed work and rendering text. The surface you will be designing on should be layout paper, which is available in pads of various sizes and which, because it is fairly transparent, will allow you to make copies and amendments simply by overlaying a fresh sheet and redrawing.

It is advisable also to have a variety of other papers at hand, offering different textures, colors, and weights.

You will also need a selection of smaller sized paintbrushes, along with a choice of colors and some white gouache paint, which is always useful for reversing images out of dark backgrounds. Finally, you will need a smooth, heavier paper or board for mounting and presenting your design ideas.

H OW TO USE THIS BOOK

This book is divided into three sections. The first section called, "Exploring Design Options" deals with all the design elements shown individually, in order to build up a picture of how it is possible to bring them together in your design work. The second section of this book, "Making Design Decisions," will show you how those elements can be applied to different situations and be changed in line with the design brief. "Fine Tuning The Design," which is the final section, deals with the complete design process and the application of the final design decisions and is illustrated with the work of some leading design houses.

■ These pages, taken from the first section of this book, demonstrate how a line representing an area of type and a shape representing an illustration or photograph can be displayed giving different emphasis to the design area.

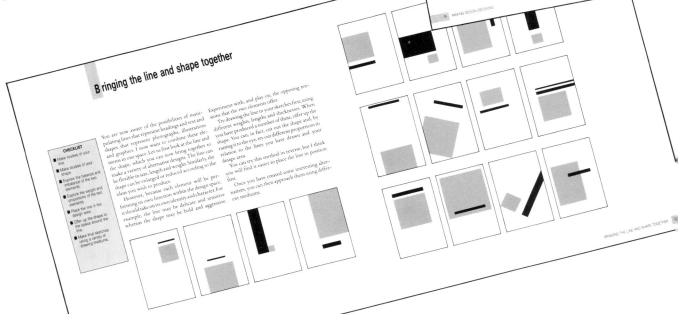

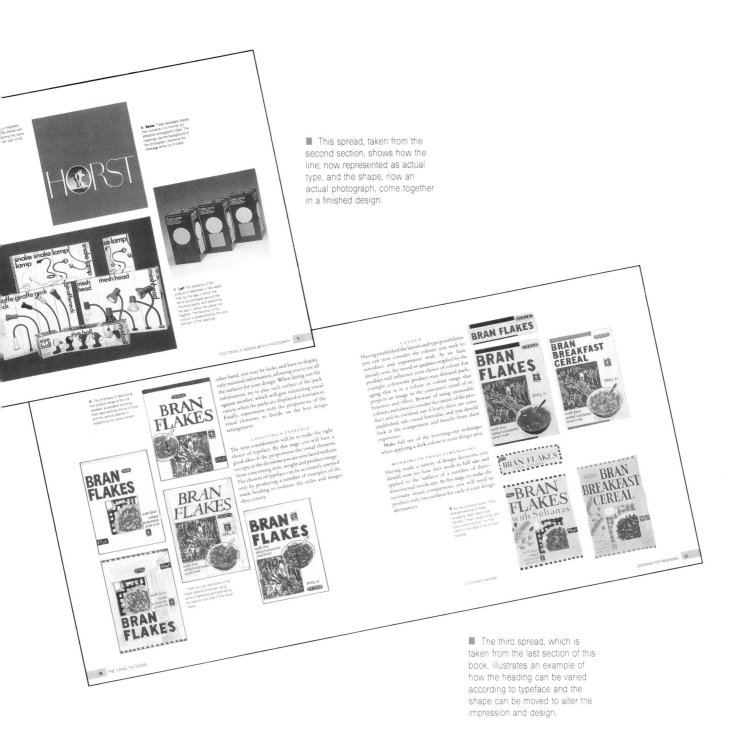

■ This spread, taken from the second section, shows how the line, now represented as actual type, and the shape, now an actual photograph, come together in a finished design.

■ **Below** These packages display their contents in a minimal but attractive photographic style. The headings use the background of the photograph; the reversing-out message white out of black.

HORST

■ **Left** The versatility of the product is described in two ways. First, by the way in which the items are portrayed around the individual packs and second by the way in which the packs link together. The flexibility of the product is established by the bold strength of the headings.

■ The emphasis in describing this product range is the link between acceptable branding style described by the choice of type and the various options in positioning the visual content.

other hand, you may be lucky and have to display only minimal information, allowing you to use all the surfaces for your design. When laying out the information, try to play each surface of the pack against another, which will give interesting visual variety when the packs are displayed as information. Finally, experiment with the proportions of the visual elements, to decide on the best design arrangement.

CHOOSING A TYPEFACE

The next consideration will be to make the right choice of typeface. By this stage you will have a good idea of the proportions the visual elements occupy, so the decisions you are now faced with are those concerning style, weight and product image. The choices of typeface can be accurately assessed only by producing a number of examples of the main heading to evaluate the styles and images they convey.

Here you can see some of the visual options, produced using various typefaces and alternating the position and size of the visual matter.

COLOUR

Having established the layout and type possibilities you can now consider the colours you wish to introduce and experiment with. As we have already seen, the mood or qualities implied by the product will influence your choice of colour. For example, a domestic product may demand packaging that is in a colour or colour range that projects an image in the customer's mind of its function and effect. Beware of using unsuitable colours, and always consider the nature of the product and its eventual use. Clearly there are some established, safe, visual formulae, and you should look at the competition and benefit from their experience.

Make full use of the reversing-out technique when applying a dark colour to your design area.

WORKING IN THREE DIMENSIONS

Having made a variety of design decisions, you should now see how they work in full size and applied to the surfaces of a number of three-dimensional mock-ups. At this stage, to make the necessary visual comparisons, you will need to produce only two surfaces for each of your design alternatives.

■ As the concepts evolve, more detailed versions of these packaging ideas need to be created. These visuals show, with colour and precision, the final effect of one face of the printed package.

continued overleaf

■ The third spread, which is taken from the last section of this book, illustrates an example of how the heading can be varied according to typeface and the shape can be moved to alter the impression and design.

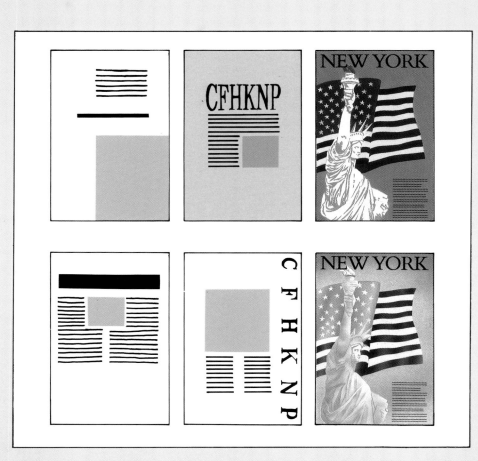

■ These six illustrations demonstrate the progression from line and shape, to letter form and shape. Finally, you see examples of how letter form and image come together to make a single design.

THE BASIS OF DESIGN

The basis of design is the bringing together of various elements into one area to achieve an interaction that will communicate a message within a given context. The message may be conveyed and even manipulated through the careful visual juggling of the elements that are to be used within the design area. Essentially, these elements will be words, photographs, illustrations, and graphic images, combined with a controlling force of black, white, and color.

I shall encourage you to look at and explore the creative potential of these elements through experimentation. Initially, I shall divide up all the design elements, taking them one by one in their most basic visual forms — as simple lines, geometric blocks, and free shapes. You will be able to set up a working design arena within which you can experiment with these elements, moving them around and assessing their visual powers, both independently and in relation to one another, and as you do so you will experience a sense of creative awareness.

As this section of the book progresses, you will become aware of the visual options that each of the elements can offer and thus gain a greater understanding of the choices open to you as a designer.

In the early stages I shall concentrate on the use of black and white images in order to develop your awareness fully, before moving on to the broader dimensions offered by the introduction of color. You will also discover how to enlarge or reduce the elements, effectively changing the power of both the visual and the written messages.

CHOOSING THE RIGHT ELEMENTS

At some point in the design process you will need to decide which elements are either essential or creatively desirable as components of your design.

It is probably prudent to minimize the number of elements in the initial stages. In my view a great many well-conceived pieces of design are successful simply because they make full visual and creative use of a limited number of design elements. First, see how well the work develops using one element. Then sparingly introduce the other ingredients, making sure that they do not overwhelm the design. Never use anything for its own sake; always consider and justify its inclusion as a contributor to the overall design effect.

C hoosing a shape to work on

CHECKLIST

- What are the first decisions to be made?
- How do you arrive at these decisions?
- Consider the project in hand.
- Draw a number of shapes.
- Try cutting out some shapes.
- Use a variety of materials.
- Choose the shape you like.

Let us start on your design. What are the first decisions to be made? These must be the shape, size, and proportions of your design area. How do you arrive at these decisions? Initially, you must consider the nature of the project in hand and what would be the most creative but relevant shape, size, and proportions for that job; but I would suggest that at this stage you put to one side any foreseeable restrictions, since these will only hinder your creativity. The only practical way you can discover the variety of possibilities is by roughly drawing a number of variations on your pad. You may later find that you need to revise your original design, but do not worry because this development will take place naturally.

Finally, many graphic designers would experiment with these shapes by cutting them out of various attractive materials — colored paper, light boards, textured papers, laminated papers, in fact, any visually desirable surface. You may even wish to examine the visual possibilities of cutting out shapes from newspapers and magazines. This will give you the opportunity to manipulate visual matter that has already been printed but that you can control when cutting the shape. Pin these up, study them, and let them tell you which you find the most attractive.

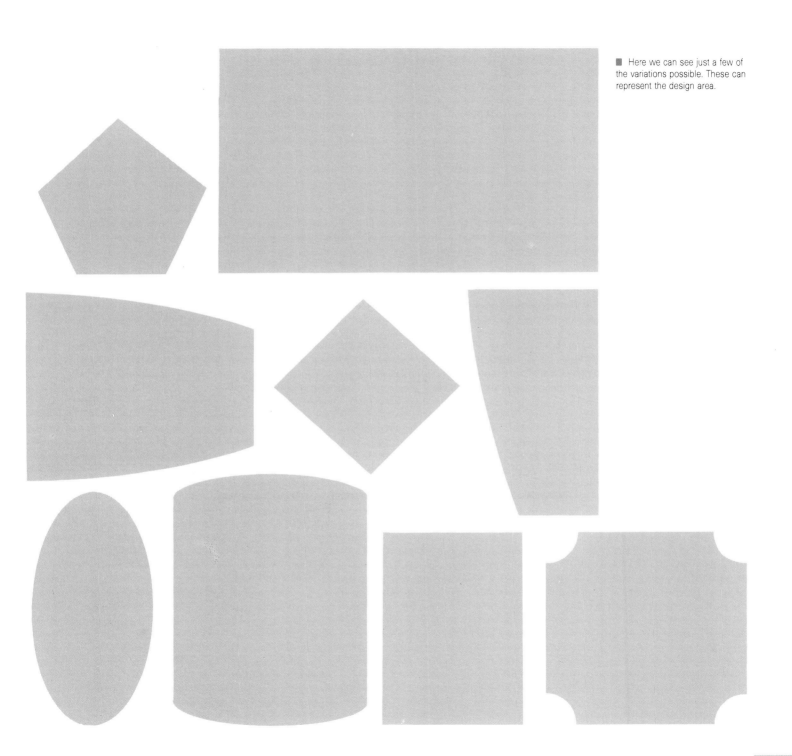

■ Here we can see just a few of the variations possible. These can represent the design area.

Laying out and positioning the first line

You are now aware of the various possibilities available in choosing a shape to work on. We can move on to the next stage, which is making a decision on how to position information using simple and quick visual statements.

Most designs will involve words, which will be presented as headings or body copy, known as text. The first example you will deal with will be the placing of a single line to represent a heading. The purpose of this is to move the line around inside your shape to establish where the line presents the most visually dynamic position in the space. As you do this you will find that you are more naturally attracted to some positions than to others. This discovery is the first in the natural creative process.

From this point you will be able to use your judgment, guided by your creative eye. Experiment extensively with the line, trying every conceivable position in order to gain an understanding of the control between space and the marks you are making. You will begin to recognize how the positions will affect the feeling of tension within the space according to the weight, position, and length of your line.

Remember, in the early stages it is easier to work on smaller, scaled-down versions of the actual design size, since you can place many of these on a single sheet of paper and compare them with each other. This process is known as making thumbnail sketches.

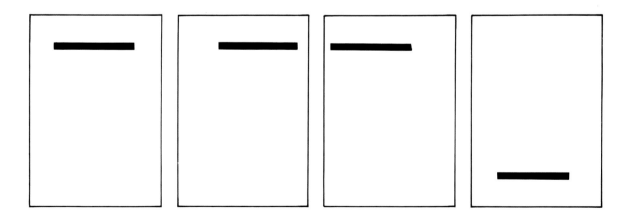

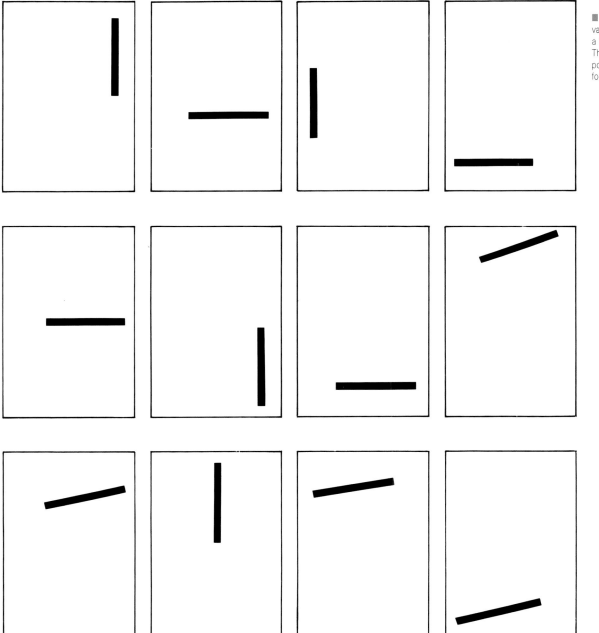

Here you can see a number of variations showing the position of a line placed in the design area. These represent just a few of the possibilities. Try some alternatives for yourself.

Choosing the right proportions for your line

CHECKLIST

- Expand and contract your line.
- Balance the space with the weight of the line.
- Reconsider the position of your line.
- Represent the volume of your line accurately.
- Experiment extensively.

I have referred to the mark with which you are making visual experiments as a line. Now, let us develop the line and explore its possibilities. You have already had some experience of placing the line that represents the heading in a number of positions within your chosen shape. You can now begin to expand and contract the proportions of your line to see how much of the shape you wish it to occupy. The purpose of this step is to make a decision on the importance and prominence of this feature in your design. Pay particular attention to the space you are left with. Balance the space with the weight of the line, leaving more white space at the top, bottom, or sides. You will also begin to realize that your earlier creative decision on the position of the line may no longer be relevant, since your creative judgment will be influenced once again by the change in the size of the elements of the line. A heavier line may feel better in one particular position within the space, whereas a slimmer line may naturally gravitate toward another position.

I would like you to be careful, when deciding on the width and weight of your line, to be fairly accurate in representing its volume as you change the overall proportions. In other words, a thin, long line, when shortened, would become fatter.

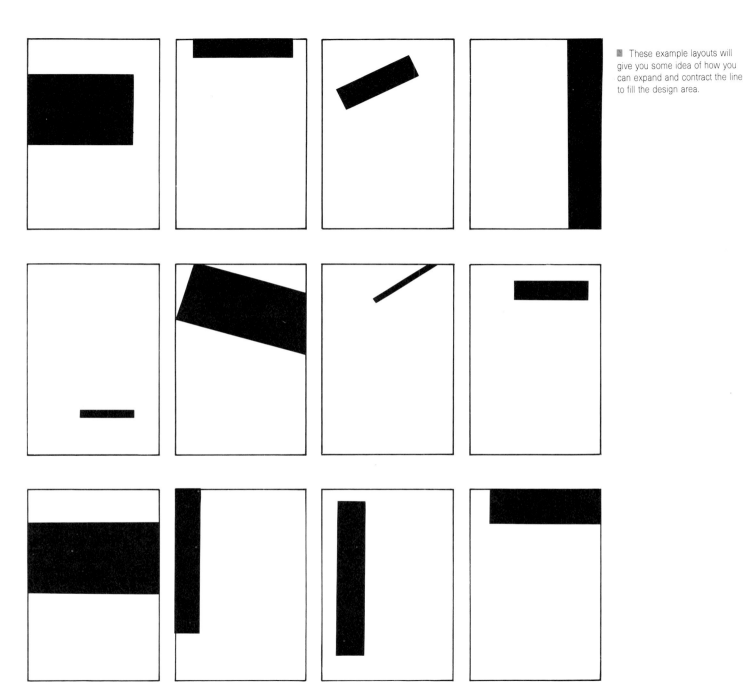

These example layouts will give you some idea of how you can expand and contract the line to fill the design area.

Introducing more lines to your layout

CHECKLIST

- ■ Consider more lines in your design.
- ■ Separate the lines visually.
- ■ Distinguish heading lines.
- ■ Distinguish text lines.
- ■ Vary the weight and size of the marks.
- ■ Make creative judgments.
- ■ Make use of the space around your lines.
- ■ Experiment with different instruments.

Rarely will there be a situation in which there is only one line or heading to be incorporated into your design, so now you must consider the possibility of more lines. These lines will represent copy or text, as opposed to the heading. This text is known as body copy, and it will naturally be smaller and possibly lighter than your heading. There could be any number of lines representing your text, and this, of course, will be determined by the nature of the project you are working on.

The first problem to solve is how to represent headings and text in the form of lines, so that they are visually distinct. When producing thumbnail sketches you will need to represent the lines for headings differently from the lines for text by varying the weight and size of the marks you make. At this early stage I suggest that you work with a few lines and a single heading. Assess the balance and weight, contrast the marks tonally, and, once again, make aesthetic judgments with your creative eye concerning the proportion, shape, and size of these marks. Extract every permutation of layout until you are satisfied that you have exhausted the possibilities.

One important consideration for any layout is how the space around the lines is used. This should always be viewed in conjunction with the marks you are making.

A method of insuring that the marks vary is to change the tools you are using for this process.

Experiment with different instruments, such as pencils and markers, or with any other drawing medium that gives you freedom to express your ideas visually.

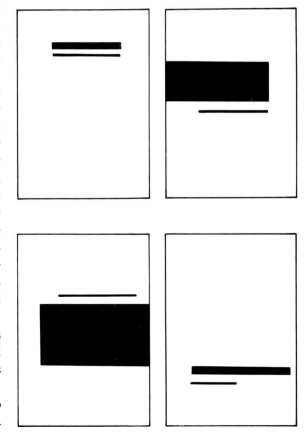

■ Moving on to developing the use of the line further, here you can see how a balance can be struck between the larger element and its more delicate components.

continued overleaf

■ Further examples of the balance between a heavy line and its more delicate counterpart.

Introducing shapes to your layout

CHECKLIST

■ Create some shapes for yourself.

■ Position them within the design area.

■ Keep your shapes to the same scale.

■ Evaluate your shapes in the design area.

■ Produce thumbnail sketches in different media.

In addition to the problems of positioning lines you will also encounter shapes. These shapes may, in fact, be photographs, illustrations, or graphics, but I shall deal with these by asking you to view these elements as solid shapes. They can then be manipulated in the same way as you dealt with the lines on the previous exercises.

These shapes may take any form, and you should take advantage of this by creating some for yourself and positioning them within the design area.

To develop your awareness of how shapes will be affected by the space that surrounds them, you should create a variety of examples, keeping them roughly to the same scale as one another. These could be cut out of some colored paper and moved around the design area. Try a number of different shapes, separately positioning them in the same design area to evaluate the effect created.

Although at the moment your shapes are all to the same scale, by producing them as thumbnail sketches in different media, you will be able to control not only the space around your shape but also the visual impact it has within the space.

■ Pick some simple shapes and move them around the design area. See which of these gives you the most pleasing effect.

Choosing the right proportion for your shapes

CHECKLIST

- How large or small is the shape to be?
- How much of the design area should it occupy?
- What position should it take?
- Make a viewing frame.
- Experiment with the viewing frame.
- Produce thumbnail sketches of your chosen images.
- Experiment with different drawing media.

The next hurdle to overcome is how much of your design area is to be filled with your shape. Is it to occupy the entire area? Or will it be reduced almost to a dot on the page? Naturally, the size of your shape may eventually be affected by the other elements or components of the overall design, but at this stage your first concern is to experiment creatively.

To assist yourself in enlarging and reducing the shape, make a simple viewing device by cutting out a scaled frame that has the proportions of your design area. If you lay a drawn version of your shape on your work surface and hold the viewing frame so that you can look at the shape through the frame at different distances from your eye, you will find you can reduce or enlarge the image of your shape and the position it occupies. Try this first with a simple plastic photographic transparency mount.

By now, what should be emerging is the feeling of enjoyment that is derived from controlling visual images. The next step is to harness this enthusiasm and express it on paper by producing the drawings of your chosen images. Once again, remember that you can change the balance and effect of your images by using various media.

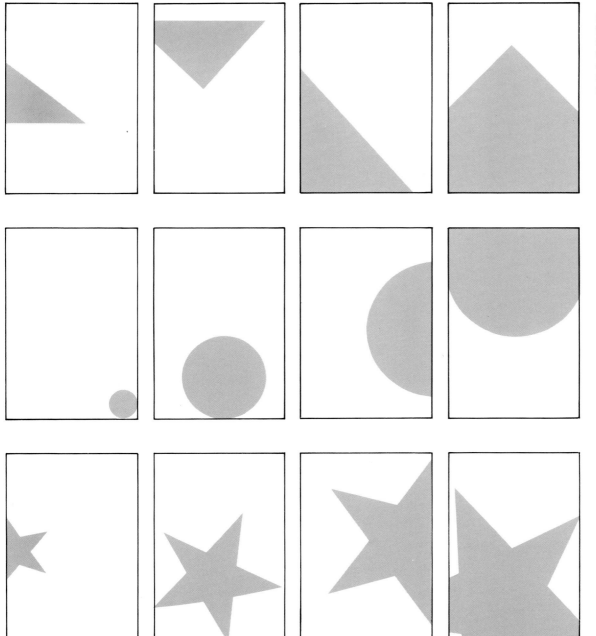

■ With the simple framing device, try out some alternative design arrangements. The examples shown here represent only a few of the shapes that can be used for this exercise, as well as the proportions they can be drawn to.

B ringing the line and shape together

CHECKLIST

- Make studies of your line.
- Make studies of your shape.
- Explore the balance and imbalance of the two elements.
- Explore the weight and proportions of the two elements.
- Place the line in the design area.
- Offer up the shape to the space around the line.
- Make final sketches using a variety of drawing media.

You are now aware of the possibilities of manipulating lines that represent headings and text and shapes that represent photographs, illustrations, and graphics. I now want to combine these elements in one space. Let us first look at the line and the shape, which you can now bring together to make a variety of different designs. The line can be flexible in size, length, and weight. Similarly, the shape can be enlarged or reduced according to the ideas you wish to produce.

However, because each element will be performing its own function within the design space, it should take on its own identity and character. For example, the line may be delicate and sensitive whereas the shape may be bold and aggressive.

Experiment with, and play on, the opposing tensions that the two elements offer.

Try drawing the line in your sketches first, using different weights, lengths, and thicknesses. When you have produced a number of these, offer up the shape. You can, in fact, cut out the shape and, by raising it to the eye, try out different proportions in relation to the lines you have drawn and your design area.

You can try this method in reverse, but I think you will find it easier to place the line in position first.

Once you have created some interesting alternatives, you can then approach them using different media.

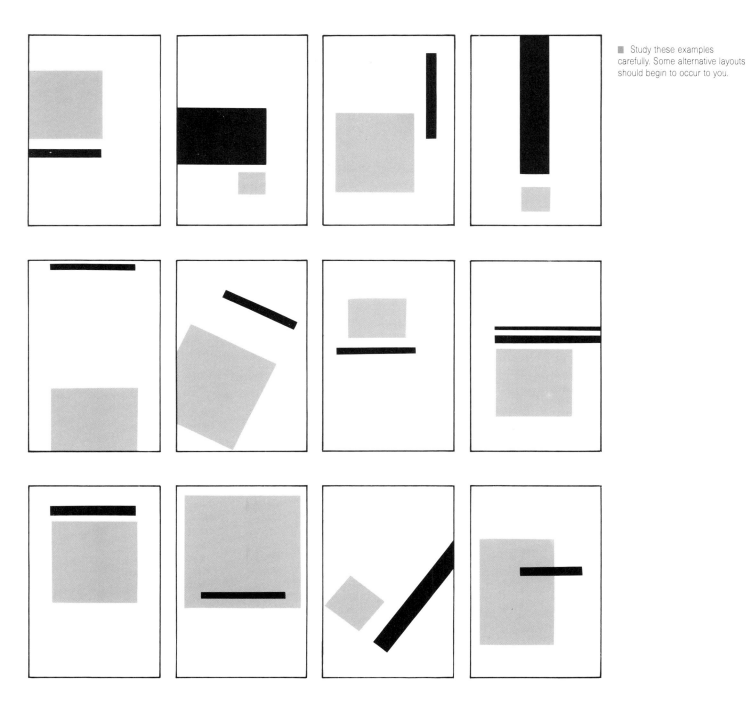

Study these examples carefully. Some alternative layouts should begin to occur to you.

Introducing more lines to your design area

CHECKLIST

- Choose the number of lines to be used.

- How will they be organized?

- Find a formal arrangement.

- Make thumbnail sketches of your lines.

- Vary the weight, size, and proportion of your lines.

- Offer your shape to the lines.

Now that you have explored the options open to you with one shape and one line, I would like to move on to the introduction of more lines. These additional lines will represent body copy, with the original line representing the heading.

The first problem you will encounter will be the number of lines to be used; the examples on this page will serve as guides. The next problem is to come to terms with the way you wish to organize these lines. Naturally, because they represent text, there has to be a formal arrangement for placing them within the design area. Finally, depending upon the number of lines or the effect you wish to create, you may want to divide these lines into columns of text, such as you would see in any newspaper or magazine.

The next part of the problem is the introduction of your shape into the same design area. The process you will use to establish the balance between lines and shape will be no different from the approach used on previous occasions, except for one consideration. You will produce, as you have done, the sketches of ideas, placing the lines in your design area using different weights, heights, and sizes. However, it is important to bear in mind that your lines are better kept in controlled, measured areas within your design area, appearing as neat and calculated visual components.

Some of your lines can occupy most of your design area, leaving just enough room for a tiny shape, or, alternatively, the lines may occupy a very small area, allowing more freedom for the placing and size of the shape.

Finally, keeping the lines parallel, accurately spaced, and in consistent patterns, use a variety of weights and sizes. Once you have drawn up a number of options for your lines, you can introduce your shape, scaling it up and down to get a feel of how it functions in your design. By now you will be familiar with different drawing media, so exploit these for the most creative effect.

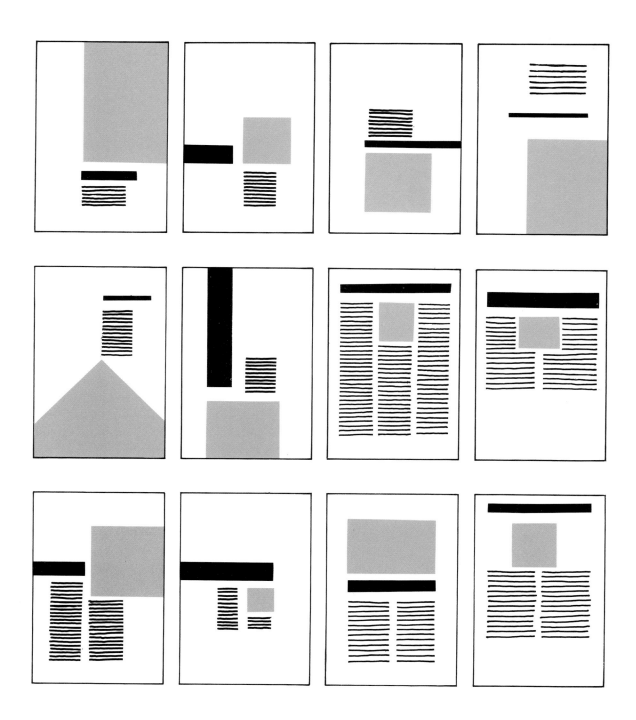

Introducing lines to various shapes

CHECKLIST

- Draw your shape first.
- Use a number of different shapes.
- Keep the design area consistent.
- Draw your lines on transparent paper.
- Try a number of versions.
- Offer these up to your shapes.
- Make a series of sketches.

You will already have discovered that to some extent the shape you have chosen will determine the best layout for your lines. Now you should experiment further, changing the design of the shape and so affecting the visual decisions you have to make regarding the positioning and the weight of the lines.

In order to establish the position and weight of the lines, you will first need to draw your shape in your design area. Draw a number of shapes of different sizes, each in a separate design area, making sure that the areas are of the same size.

At this stage you will need to look at the way your lines are going to fit with the shape. A simple method is to draw your series of lines on transparent paper and offer these up to your design area to assess the most effective layout. Naturally, this method can be repeated using different weights, thicknesses, and lengths of line. Some designs may even benefit from the lines following the contours of your shapes. With the overlay method described here you can experiment extensively without having to come to final creative decisions until you are confident that you have exhausted all possibilities.

■ See which of the examples shown appeals to you the most. Take this idea and experiment with some alternative options.

L aying out and positioning the line as a heading

So far you have dealt with lines and shapes. As discussed, the lines represent words in your layouts. You should now start working with letter forms on a line that represents words. This presents a major hurdle to overcome, simply because so far you have been looking at shapes and space in order to make aesthetic judgments. Now, however, the introduction of familiar forms presents another problem — namely that the letter forms themselves will also pose a challenge to your visual judgment.

So that you recognize the problem for yourself, I want you to take a random selection of capital letter forms and use the visual examples on this page as guides. Draw two parallel lines and render your letter forms between the two lines, staying within the confines of the lines and making sure that the letter forms within your examples are drawn to the same size. These can be produced on the transparent paper to be offered later to the design area for assessment.

Some consideration should certainly be given to the spaces between the individual letter forms, since these also become an essential element of the overall visual balance.

By using various thicknesses and density in your drawing media you will be able to make different impressions and marks, producing different effects for your letter forms.

To get a feel for the heading within the design area, move around the various options you have created until the satisfactory positions become obvious to your creative eye.

CFHKNP

CFHKNP

CFHKNP

CFHKNP

The examples shown here are all based around the same style of type. Try some alternatives with different styles of type to assess the visual effect.

CFHKNP

CFHKNP

CFHKNP

CFHKNP

CFHKNP

CFHKNP

CFHKNP

CFHKNP

CFHKNP

C hanging the size and spacing of the headings

CHECKLIST

■ Enlarge and reduce your letter forms.

■ Change the proportions of your line of letters.

■ Move these around in your design area.

■ Experiment with the spaces between the letters.

■ Use different instruments.

In order to develop these letter forms and explore their creative possibilities, you should now begin to enlarge or reduce the letter forms you have chosen, making sure that they are all to the same scale and size within each separate line of letters.

You have already experienced the placing of the line of letters in a number of positions within your chosen area. You can now begin to expand, contract, and elongate the proportions of your line of letters to see how much of the area you wish them to occupy. The importance of this, as you have already experienced with a single line, is to decide how prominent the letters are going to be.

Balance the space between the line of letters and what is left in the design area. Look for the drama you can create by producing bold letter forms and for the subtleties possible with small and delicate letter forms. Look at the spaces between the letters themselves. See how far apart you can spread the letters without loss of visual cohesion. Squash them together until they become almost a solid black mass. Again, try different instruments to see what effects they create. Your creative judgment should be pushed and pulled with the visual influences that are emerging within the design area.

CFHKNP

CFHKNP

CFHKNP

C F H K N P

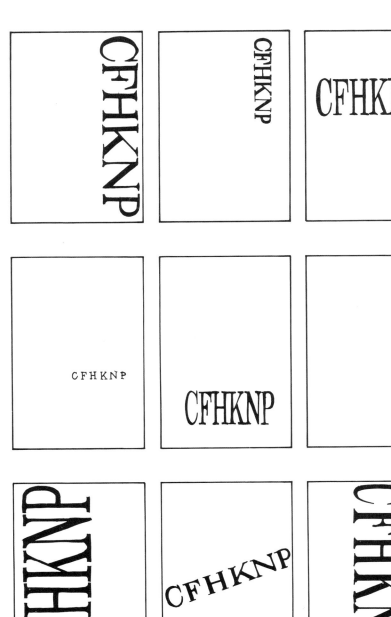

■ To help you view the enlarged letter forms, return to the viewing device mentioned earlier.

Introducing words as headings with lines for text

CHECKLIST

- Consider the relationship of heading to text.
- Experiment with the weight of text and heading.
- Experiment with the space around the text and heading.
- Try dividing the text into separate sections.
- Try out many alternatives.

Most pieces of design work will include a heading, which will probably be represented in a larger size than the body copy that follows. The letter forms with which you have been experimenting would represent headings, and you can now consider the problem of relating these to text. I shall focus upon the balance between the two forms. There are numerous combinations you can explore in creating a harmonious, dynamic, or sensitive balance within these elements. For example, a bold, heavy, and overpowering heading combined with fine, delicate lines representing text will give the feeling of an important message being conveyed from the heading, with sensitive copy to follow. Alternatively, a modest heading of almost the same weight

as the text lines will describe a more sober and formal approach to the message to be conveyed.

You have now established that letter forms are used to convey images and messages.

Now move on to the design area. Although this exists only as a white space, once again the visual components in that area can be creatively balanced to convey the image you are looking for. You must experiment with the positioning and size of your heading and lines within this area. Look at and assess the effect you wish to create. You may need to separate the text into divisions in this space. Try out every idea, for only this can help you to discover new arrangements for yourself.

■ Illustrations 1, 2 & 3 show the various techniques you can adopt for rendering the lines indicating the text. The first shows parallel lines; the second is known as blocking in type (or em-ing) and the third shows the text rendered in position. You can also show just the first word and last used in the text. This will give you or your client a positional key to the written matter.

1

2

3

Making shapes with headings and lines for text

CHECKLIST

- Draw some shapes.
- Fit your heading and text within the design area.
- Try different weights and sizes of heading.
- Try different weights and sizes of body copy.
- Use the viewing device.
- Produce some thumbnail sketches using different media.

You should now be aware that the heading and lines for text are already forming something resembling a shape within your design area. I shall now look at the manipulation of a heading and lines combined to produce visual effects of their own.

At this stage, because you are dealing only with letter forms and not with actual words, you are able to divide your heading where you choose. This gives you enormous creative freedom. In the same way, you have no actual words in your text, and this also allows you freedom to experiment.

There are now many more options open to you in the design process. For example, you could enlarge the first letter of your heading, running the rest of the heading smaller, with a squared–off slab of light body copy underneath. Alternatively, you could make pyramid shapes, circles, or diamonds, or develop any one of numerous other ideas.

Having enjoyed creating some interesting shapes, you can now move on to positioning this arrangement in the design area. I think it would be helpful to return to using the viewing frame mentioned earlier. By moving this backward and forward from your eye, you can establish both scale and position within the design area. Once you have some interesting arrangements, you should then make some thumbnail sketches. Remember that the media can also affect the visual balance of your shape.

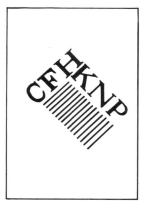
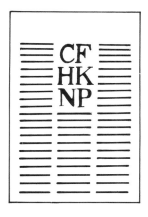
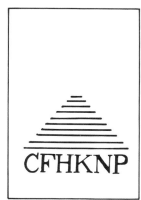

Here we have a selection of alternative shapes made with lines for text and letter forms for headings. By changing the size, shape and proportion of the image, you should be able to create some alternative ideas.

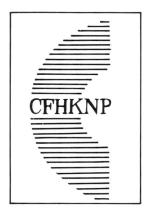

Introducing a heading and lines of text to a single shape

CHECKLIST

- Mark out a number of design areas.
- Cut out your shape in a number of sizes.
- Move the shapes around within the design area.
- Trace around the shape.
- Draw in the heading and text.
- Fill in the shape.
- Try this with different instruments and media.

You are now faced with the problem of bringing a heading and some text together with a shape within the design area. The shape, as I have said before, will represent perhaps photography or graphics. Remember, the role of these elements will be to perform their own function within the design. For example, you may wish the shape to play only a secondary role and the text to be prominent. Alternatively, the shape may occupy almost the entire design area, whereas the heading and text are merely readable. It is up to you what effect you wish to create. The weight and fullness of your design, or even its emptiness, are under your control, as have been all the creative and visual decisions so far.

In order to test the possibilities, as you have previously done with your thumbnail sketches, you should mark a number of design areas on your paper to serve as sketching areas. Next, cut out your shape in different sizes to represent the graphics. Take these cut-outs and move them around within the design area, bearing in mind all the time where you wish to place the heading and text. When you arrive at an appealing arrangement, trace around the shape, draw in your heading and text, and fill in the shape; you should be left with a design to consider. Produce many alternatives so that you can go through the selection process, and once again, try out different media.

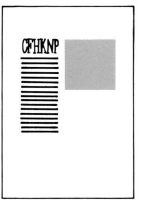
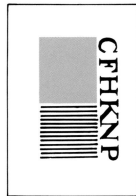
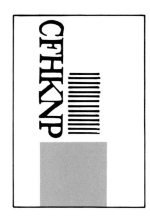

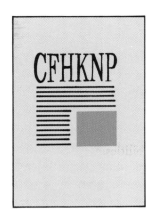
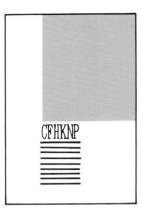
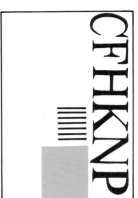

In addition to playing around with headings, text and shapes you can change the appearance of your design by the instructions that you give to the printer. The examples here show you some of the alternatives. **Top left** has the solid lines and shapes overlaid on to a tint. The shape in the example **top right** is enlarged to the size of the design area and the text and headings are reversed out of the shape; in contrast to this **bottom left** has the text and headings overprinting the shape. Another approach shown **bottom right** is to reverse the lines or shape out from a tint.

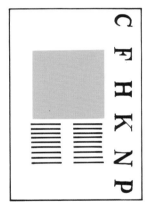

Introducing headings and lines of text to various shapes

CHECKLIST

- Mark out a number of design areas.
- Produce some headings.
- Decide on the form and position of your sub-headings.
- Indicate your text as a series of lines.
- Make a number of studies.
- Consider their balance.
- Introduce your shapes.
- Experiment with the interplay of shapes and text.

Whereas some designs have only a single heading, others require additional headings, known as sub-headings. These raise a number of problems. First, the headings and sub-headings will need different emphasis. Second, your text will need to be a still different weight. Third, you are going to have to make decisions on how much space you need between your main headings, sub-headings, and text. Finally, you will have to decide where the text is to be split and whether it requires more than one column. Only now can we introduce another factor — a shape or a variety of shapes.

Naturally there will be many creative alternatives and ideas emerging from the interplay of all these elements. Do remember that I have discussed many methods of experimenting with shapes and forms, so use these methods.

How, then, do you tackle the problem of putting your ideas down on paper?

The headings will be produced once again as a series of letter forms. Your sub-headings can be either heavy lines or a formation of smaller letters. Your text will once again be a series of lines.

The balance between these elements should be considered first. Once you have realized some pleasing layouts you can then consider the shapes. These can be cut out and moved around the design area. At this stage you may wish to run the text around the contours of your shape or shapes, merging them with harmonious unity. Another option may be simply very formal columns of text surrounded by measured space and separated in a calculated way from your shapes. Remember, whatever you do, you are looking for an interesting visual interplay between these elements.

■ Try out some alternative layouts using perhaps just one of the examples shown on these pages.

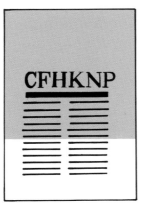
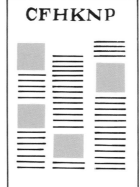
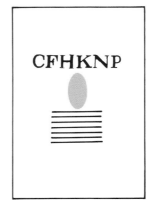

Becoming aware of different typefaces

You have looked at the use of letter forms to represent words and by now have had some experience of drawing them to create different visual effects. When you are preparing a layout using words, you will, in fact, need to be familiar with the typefaces that are available.

Typefaces are the different styles of letters as they are printed. It is essential that the typeface chosen for, say, a heading be consistent throughout that heading and that the typeface chosen for a piece of body copy also be consistent throughout. Usually you will choose a typeface by looking at a whole alphabet of letters in the same typeface, so that you can see for yourself the style and image created by each individual letter as it appears in that typeface.

There is an enormous range of typeface styles available to you, giving you tremendous creative freedom to express your ideas. Although you need to be consistent with the style of typefaces you use, you will often find that one style of face has many different weights. You may even find that there are also condensed or expanded versions of the same face. For example, a popular typeface known as Helvetica comes in an enormous choice and range of weights, sizes, and variations.

The other point I have not yet covered and which you must consider is the use of capitals, known as upper case letters, in conjunction with the small letters, known as lower case. Naturally, when you draw a line of type for your heading you will draw to the height of the capitals. Assuming that the heading will be in upper and lower case, you should also draw in the line for the placing of the lower case letters.

You are now ready to select a typeface. Lightly draw your parallel lines for upper and lower case letters, and imitate visually with selected letters the typeface you have chosen. When you are confident with this procedure you can then test it in the design area. Look very carefully for the interplay of letter spacing and the white space of the design area.

Helvetica **Helvetica**
Helvetica
Helvetica
Helvetica
Helvetica **Helvetica**

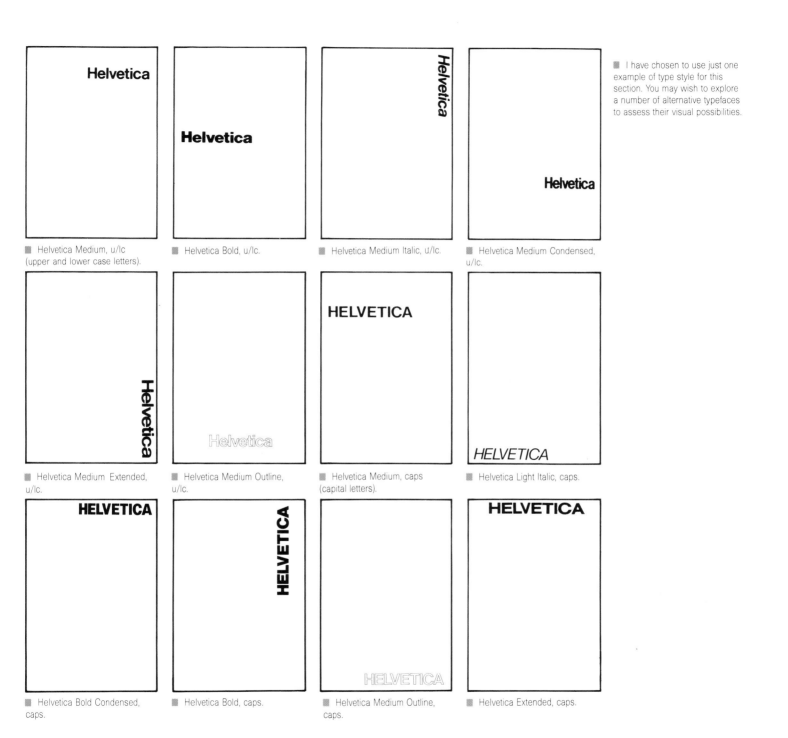

■ I have chosen to use just one example of type style for this section. You may wish to explore a number of alternative typefaces to assess their visual possibilities.

■ Helvetica Medium, u/lc (upper and lower case letters).

■ Helvetica Bold, u/lc.

■ Helvetica Medium Italic, u/lc.

■ Helvetica Medium Condensed, u/lc.

■ Helvetica Medium Extended, u/lc.

■ Helvetica Medium Outline, u/lc.

■ Helvetica Medium, caps (capital letters).

■ Helvetica Light Italic, caps.

■ Helvetica Bold Condensed, caps.

■ Helvetica Bold, caps.

■ Helvetica Medium Outline, caps.

■ Helvetica Extended, caps.

Typefaces for headings and text

Until you become fully familiar with the range and scope of typefaces and the ways of mixing styles within a single design, you should practice by exploiting the potential of only one generic group of faces so that you can gain a fuller awareness of its creative possibilities. At this stage, you should find a bold face and light face within the same typeface style.

To begin with, produce the heading in the bold face and indicate some lines of text, which will naturally be smaller, in the light face. You need only indicate the first few letters of the text — the rest can be drawn as lines. It is time that you started to realize also that the lengths of lines in your text may vary. There are three main ways of positioning these lines. Centered copy means that the lines will be balanced equally between the right- and left-hand sides. Ranged (or flush) right means that the lines of copy all end equally on a vertical line at the right-hand side, whereas the lines on the left-hand side remain unequal. Ranged (or flush) left gives you the opposite of ranged right; it is also known as ragged right. The visual examples shown on this page will clarify this.

Draw your typeface for your heading and try some different weights and sizes. Draw some examples for the text. Again, try different weights and vary the sizes. When you have exhausted the possibilities within the style of typeface you have chosen, place the heading and text together. See how they compare and balance, and allow your creativity to guide you to those that work best. Clearly, some combinations will be visually disastrous, whereas others will appear so natural and sympathetic that you may almost overlook them.

Try making interesting shapes with your area of type, following the guidelines I have discussed.

■ **Left** Samples of just some of the typefaces in the Helvetica family are shown set as blocks of text and positioned in different ways with varying spaces between the lines.
Opposite Various possibilities of Helvetica headings are combined with rendered text. Think about how the weights and shape of the text will work with the different headings.

Nos amice et nbevol, olestias access potest fier ad augendas cum conscient to factor tum poen legum odioque civiuda. Et tamen in busdam neque pecun modut est neque nonor imper ned libiding gen epular religuard cupiditati quas nulla praid om undant. Improb pary minuit, potius inflammad ut coercend magist and et dodecendesse videantur. Inviat igitur vera ratio bene sanos adzum iustitiam, aequitated fidem. Neque hominy infant aut inuiste fact est cond qui neg facile efficerd

■ Helvetica Light, u/lc, centered.

Nos amice et nbevol, olestias access potest fier ad augendas cum conscient to factor tum poen legum odioque civiuda. Et tamen in busdam neque pecun modut est neque nonor imper ned libiding gen epular re-liguard cupiditati quas nulla praid om undant. Improb pary minuit, potius inflammad ut coercend magist and et dodecendesse videantur. Inviat igitur vera ratio bene sanos adzum iustitiam, aequitated fidem. Neque hominy infant aut

■ Helvetica Roman, u/lc, justified.

Nos amice et nbevol, olestias access potest fier ad augendas cum conscient to factor tum poen legum odioque civiuda. Et tamen in busdam neque pecun modut est neque nonor imper ned libiding gen epular religuard cupiditati quas nulla praid om undant. Improb pary minuit, potius inflammad ut coercend magist and et dodecendesse videantur. Inviat igitur vera ratio bene

■ Helvetica Medium, u/lc, r/l (ranged left).

Nos amice et nbevol, olestias access potest fier ad augendas cum conscient to factor tum poen legum odioque civiuda. Et tamen in busdam neque pecun modut est neque nonor imper ned libiding gen epular religuard cupiditati quas nulla praid om undant. Improb pary minuit, potius inflammad

■ Helvetica Bold, u/lc, r/r (ranged right).

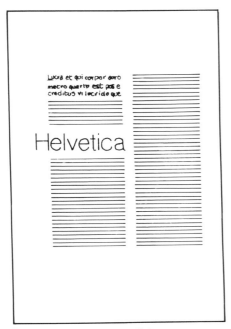

■ Helvetica Light, u/lc, text justified.

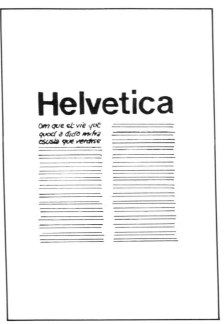

■ Helvetica Roman, u/lc, text justified.

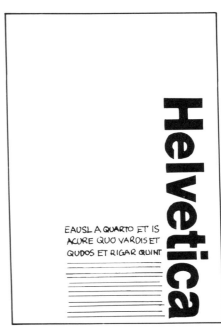

■ Helvetica Bold, u/lc, text r/r.

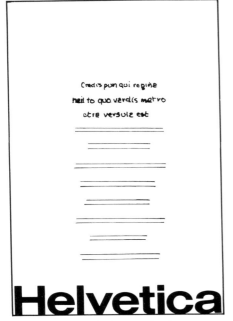

■ Helvetica Extended, u/lc, text centered.

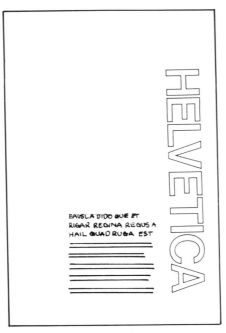

■ Helvetica Outline, caps, text r/l.

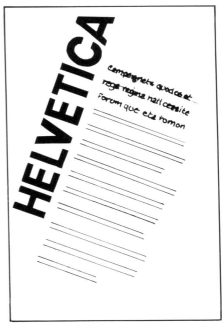

■ Helvetica Bold, caps, text r/l

Introducing more typeface styles

You are now aware of typeface styles, and I have mentioned that there is an enormous range available. This range is divided into two main categories, namely serif typefaces, which have short lines extending from the upper and lower ends of the strokes of some letters, and sans serif, which have none. These typefaces come in different sizes, which are mathematically divided by a system known as point size. Body copy would normally be anything from 6 point type to 12 point type. You can see this for yourself by studying some typesheets, which may be seen in typography books and graphics suppliers' catalogues. By comparing the amount of copy you have with that printed in a magazine or journal you can get some idea of how much space you need for your copy.

The beauty of type is that it is ready-made for you to select according to your requirements, and it comes in all manner of visual styles enabling you to create whatever image you wish.

It is also creatively exciting to look at mixing different styles of type within one design. For example, you can now produce that really bold aggressive heading using a solid, heavy type, against the soft and sensitive appearance of the body copy, merely by choosing a light and sensitive face. However, beware: there will be times when typefaces just do not mix, and these you will have to discover. Remembering everything you have learned so far, explore the range of possible and impossible combinations by experimenting.

Antique Olive

Futura

BEMBO

Bodoni

Optima

Rockwell

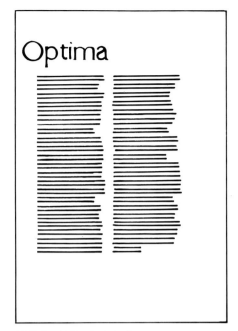

■ Optima Light, u/lc, text, r/l.

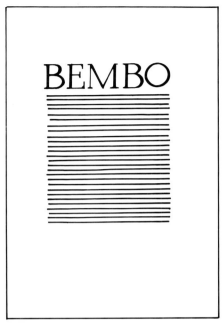

■ Bembo, caps, text justified.

■ Futura Medium, u/lc, text centered.

■ Antique Olive Roman, u/lc, text, r/l.

■ Rockwell Bold, u/lc, text, r/ l.

■ Bodini, u/lc, text, r/r.

Choosing the right typeface for the design

CHECKLIST

■ Extend your knowledge of the typefaces available.

■ Choose a number of objects.

■ Choose a typeface to describe each object.

■ Apply your chosen designs to the design area.

■ Enlarge and reduce the space these occupy.

■ Produce a number of versions in different media.

So far I have disregarded the purpose of the design and asked you merely to make aesthetic judgments. Perhaps you should now consider the function and application of your design, because these must influence your visual decisions. In other words, what is the most appropriate typeface for your design? As an example, imagine you are designing a poster for a company manufacturing concrete, and the heading to be used is the word "CONCRETE." Naturally, you are not going to look for the most delicate and timid of typefaces, because of the nature of the word, and the commodity itself suggests boldness and strength. By contrast, an exhibition of flowers would naturally inspire another approach.

Although the examples I have used here are obvious, there is still a great deal of scope for subtle alternatives in your creation.

To discover the vast range of possibilities for yourself, I suggest you spend some time choosing a variety of visually tempting objects that can be rep-resented by a word or words. Choose for each of these a typeface that not only expresses the essence of the object but also conveys visually a sense and feeling of the object. Now apply the words to the design area, remembering that proportion and scale will affect the way your visual meaning is being conveyed. Revert to the viewing frame to assess how much space should be allowed to surround your word or words.

Experiment with different media to see how the tonal effects will redefine the meaning.

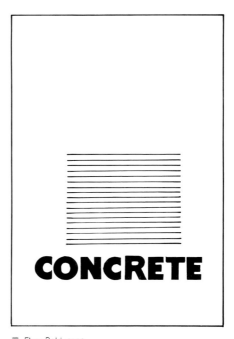

■ Flyer Bold, caps.

■ Cancellaresca Script, u/lc.

■ Compacta, caps.

■ Cameo Rimmed Condensed, caps.

■ Franklin Gothic Condensed, caps.

■ Charrette, caps.

■ Slogan, u/lc.

A dding a single color to headings

Naturally, there will be situations when you will be able to produce a heading using a single color. This again needs to be considered very carefully. Let me return to my example. The word "CONCRETE" may be produced using color. Clearly, some colors can be instantly rejected as inappropriate for the subject. Pink, for example, would convey the wrong image. On the other hand, it might be ideally sited to the flower exhibition. The final decision on what is appropriate will be determined largely by the nature of the object to be represented and the context in which it is to appear.

Another consideration should be the weight of the type of your heading. Should you wish to use a light color, pay special attention to the size and proportion of the type since this may prove unreadable if it appears too faint.

You will also need to work with color media and instruments. You will benefit from starting with colored pencils before moving on to more expensive markers, although it is useful to note that nowadays the markers are obtainable in a range of colors that are compatible with printers' inks.

R eversing letter forms out of a single color

A useful method of contrasting your letter forms in the design area is to reverse them out of a solid color, leaving the letters themselves as the white of the paper. Some interesting shapes can be created around your letters, and this method is widely used in the creation of company logos, magazine covers, headings on posters, and so forth. The advantage of this approach is that it will give you an opportunity of making a special feature out of your important heading.

To achieve this effect you can first draw your lettering and fill in the color around the image. Alternatively, you can produce a solid color in permanent markers and white out your lettering using a brush and designer's gouache. Again, experiment with the proportions of the reversed-out text within the design area.

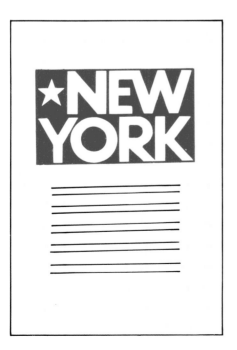

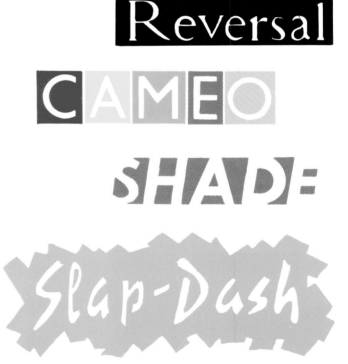

A dding colors to text

Moving on from the use of colors within headings, you should now explore the variety of effects that can be created by adding color to the text. When considering your choice of colors pay special attention to their readability. Some colors may prove inappropriate or unreadable. There are, however, some interesting creative experiments you can try with your colors. For example, you may wish to separate more important information with the use of a color.

You may also be able to use two tones of the same color to give a different visual emphasis to various parts of the copy. You may even wish to separate your copy and reverse one section out of a colored shape. There are any number of creative formulas you can experiment with.

Before attempting to produce elaborate ideas, you are well advised to produce some simple color scribbles to formulate the basis of your idea. This will also help you to determine the use of the design area.

Finally: a carnival of color is not always the best way to present a design, and the subtle use of compatible colors or shades of one single color can often create the most dynamic effects.

Splendida porro oculi fugitant urtantque tueri , so ipsius, et alte aera per purum grauiter simulacra quicumque est acer adurit saepe oculos, ideo quod Lurida praeterea fiunt quaecumque tuentur arquati rerum, multaque sunt oculis in eorum denique mixta in luce tuemur propterea quia, cum propior confestim lucidus aer, qui quasi purgat eos ac niq multisque minutior, et mage pollens Qui simul

Splendida porro oculi ipsius, et alte aera per quicumque est acer adu Lurida praeterea fiunt rerum, multaque sunt oc in luce tuemur propter confestim lucidus aer multisque minutior, et m continuo rerum simulacr nequimus propterea quii ne simulacra possint ul propterea fit uti uideant perit eius plaga, nec ad crebris offensibus aer tamen ut coram quae sur moueri et uestigia nostra sequentem nam nil ex ordine certis lumine uideatur, quae fuit umbra dispereunt, quasi

umbras Nec tamen hic oci sint lumina necne, umbraqi ratio discernere debet. uehimur naui, fertur, cum campique uidentur quos adsiduo sunt omnia motu, pari ratione manere et lu montis classibus inter cursare, columnae usque ruere omnia tecta minari quos tibi tum supra sol mi sagittae, uix etiam cursus ingentibus oris, interiectaq digitum non altior unum, quantum caeli patet altus Denique ubi in medio nobis ferre uidetur uis et in adu nobis ratione uidentur Por tamen parte ab summa donec in obscurum coni

Splendida porro oculi fugitant uita
ipsius et alte aera per purum
quicumque est acer adurit saepe
Lurida praeterea fiunt quaecum
rerum multaque sunt oculis in
in luce tuemur propterea quia
confestim lucidus aer qui quasi
continuo rerum simulacra secunt
nequimus propterea quia posterior
ne simulacra possint ullarum re
propterea fit uti uideantur saepe
perit eius plaga nec ad nostras
crebris offensibus aer Hoc ubi
tamen ut coram quae sunt

Splendida porro oculi
ipsius, et alte aera per
quicumque est acer aduri
Lurida praeterea fiunt
rerum, multaque sunt ocul
in luce tuemur propterea
confestim lucidus aer
multisque minutior, et ma
continuo rerum simulacra
nequimus propterea quia
ne simulacra possint ulla
propterea fit uti uideantur
perit eius plaga, nec ad
crebris offensibus aer Ho
tamen ut coram quae sunt
moueri et uestigia nostra

adsiduo sunt omnia
pari ratione manere
montis classibus inter
cursare columnae
ruere omnia tecta mir
quos tibi tum supra
sagittae, uix etiam cu

adsiduo sunt omnia motu,
pari ratione manere et luna
montis classibus inter quos
cursare columnae usque
ruere omnia tecta minari lar
quos tibi tum supra sol mon
sagittae, uix etiam cursus
ingentibus oris, interiectaque
digitum non altior unum,
quantum caeli patet altus hi
Denique ubi in medio nobis
ferre uidetur uis et in aduer
nobis ratione uidentur Porti
tamen parte ab summa cum
donec in obscurum coni co
Splendida porro oculi fugit
ipsius, et alte aera per
quicumque est acer aduri
Lurida praeterea fiunt quae
rerum, multaque sunt oculis
in luce tuemur propterea q
confestim lucidus aer, qui
multisque minutior, et mage
continuo rerum simulacra
nequimus propterea quia po
ne simulacra possint
propterea fit uti uideantur
perit eius plaga, nec ad

rerum, multaque sunt oculis in eoru
in luce tuemur propterea quia, cu
confestim lucidus aer, qui quasi p
multisque minutior, et mage pollen
continuo rerum simulacra secuntur
nequimus propterea quia posterior
ne simulacra possint ullarum rerum
propterea fit uti uideantur saepe r
perit eius plaga, nec ad nostras ac
crebris offensibus aer Hoc ubi suf
tamen ut coram quae sunt uereque
moueri et uestigia nostra sequi gest
sequentem : nam nil esse potest al
uidetur, quae fuit umbra corporis,
dispereunt, quasi in ignem lana tr
umbras Nec tamen hic oculos falli
sint lumina necne, umbraque quae
ratio discernere debet, nec possu
uehimur naui, fertur, cum stare u
campique uidentur quos agimus pra
adsiduo sunt omnia motu, quandoq
pari ratione manere et luna uider
montis classibus inter quos liber p
cursare columnae usque adeo fit
ruere omnia tecta minari lamque r
quos tibi tum supra sol montis ess
sagittae, uix etiam cursus quingen
ingentibus oris, interiectaque sunt
digitum non altior unum, qui lapic

At si forte ocu
tuendo bina li
corpora bina D

uni subdita
florentia lur
m suaui deu
nostra uider

nobis et membra
loco caelum, ma
undique cum cor
sensibus omnia

pergas propterea quia u
comp`isituras Praetere
oculis quae gignunt
mina multa fluunt simul
a pingunt E tenebris autem
apertos, insequiti
nuitis partibus hic e
patefecit quas ante obs
quod contra facere in tene
complet, obsiditque uias
um cernimus urbis, propt
is, siue etiam potius non
feruntur, cogit hebe
rnum saxorum structa tera
Vmbra uidetur item n
indugredi, motus hominum
bere suemus. Nimirum quia
quod liquimus eius, propt
radiorum lumina fundun
repleuit item nigrasque
umbra tueri illorum est
quod diximus ante, hoc an
itium hoc oculis adfingere
tur ire. Et fugere ad pup
adfixa cauernis cuncta t
o sunt caelum corpore cla
stantisque procul medio
una adiuter. Atria uersari
iam credere possint non s
natura uisaque extolle
uix absunt nobis missu
nia ponti aequora substrat
saecla ferarum. At conied
bet sub terras inpete tant
ora mirande sub terras ab
ndas, stantis equi corpus tr
ecimus, omnia ferri et flue
paribus suffulta colun

Lurida praeterea fiunt quaecumque tuentur
rerum, multaque sunt oculis in eorum denique
in luce tuemur propterea quia, cum propio
confestim lucidus aer, qui quasi purgat
multisque minutior, et mage pollens Qui sim
continuo rerum simulacra secuntur quae sita
nequimus propterea quia posterior caliginis
ne simulacra possint ullarum rerum coniect
propterea fit uti uideantur saepe rutundae,
perit eius plaga, nec ad nostras acies perlab
crebris offensibus aer Hoc ubi suffugit sensi
tamen ut coram quae sunt uereque rutunda,
moueri et uestigia nostra sequi gestumque imi
sequentem : nam nil esse potest aliud nisi lum
ex ordine certis lumine priuatur solis quac
uidetur, quae fuit umbra corporis, e regione
dispereunt, quasi in ignem lana trahatur Pr
umbras Nec tamen hic oculos falli concedimu
sint lumina necne, umbraque quae fuit hic ead
ratio discernere debet, nec possunt oculi
uehimur naui, fertur, cum stare uidetur : q
campique uidentur quos agimus praeter nauer
adsiduo sunt omnia motu, quandoquidem longos
pari ratione manere et luna uidentur
montis classibus inter quos liber patet exitu
cursare columnae usque adeo fit uti pueris
ruere omnia tecta minari lamque rubrum trer
quos tibi tum supra sol montis esse uidetur
sagittae, uix etiam cursus quingentos saepe
ingentibus oris, interiectaque sunt terrarum
digitum non altior unum, qui lapides inter
quantum caeli patet altus hiatus . nubila des
Denique ubi in medio nobis ecus acer obhaes
ferre uidetur uis et in aduersum flumen
nobis ratione uidentur Porticus aequali quam
tamen parte ab summa cum tota uidetur, pau
donec in obscurum coni conduxit acumen
lumen , quippe ubi nil aliud nisi

moueri et uestigia nostra sequi gestumque imitari ; aera si
sequentem : nam nil esse potest aliud nisi lumine cassus
ex ordine certis lumine priuatur solis quacumque mea
uidetur, quae fuit umbra corporis, e regione eadem nos us
dispereunt, quasi in ignem lana trahatur. Propterea
umbras Nec tamen hic oculos falli concedimus hilum. Nar
sint lumina necne, umbraque quae fuit hic eadem nunc tr
ratio discernere debet, nec possunt oculi naturam nos
uehimur naui, fertur, cum stare uidetur ; quae manet
campique uidentur quos agimus praeter nauem uelisque u
adsiduo sunt omnia motu, quandoquidem longos obitus ex
pari ratione manere et luna uidentur in statione, ea c
montis classibus inter quos liber patet exitus ingens, in
cursare columnae usque adeo fit uti pueris uideantur, u
ruere omnia tecta minari lamque rubrum tremulis iubar
quos tibi tum supra sol montis esse uidetur comminus i
sagittae, uix etiam cursus quingentos saepe ueruti ; int
ingentibus oris, interiectaque sunt terrarum milia multa
digitum non altior unum, qui lapides inter sistit per st
quantum caeli patet altus hiatus . nubila despicere et c
Denique ubi in medio nobis ecus acer obhaest flumine et
ferre uidetur uis et in aduersum flumen contrudere rapt
nobis ratione uidentur. Porticus aequali quamuis est den
tamen parte ab summa cum tota uidetur, paulatim trahit
donec in obscurum coni conduxit acumen in pelago n
Splendida porro oculi fugitant uitantque tueri : sol etia
ipsius, et alte aera per purum grauiter simulacra ferur
quicumque est acer adurit saepe oculos, ideo quod sen
Lurida praeterea fiunt quaecumque tuentur arquati, qui

Using color in headings in text

CHECKLIST

- Decide on size and shape of heading.
- Decide on shape and form of text.
- Decide on the colors you wish to use.
- Decide on the arrangement of those colors.
- Experiment by seeing the overall effect as a pattern.
- Explore the use of space within the design area.

I have discussed headings and text separately, and you have explored various color arrangements and options. You can now decide how to bring these two elements together. Creatively there are any number of ways you may wish to combine colors in text and in headings, but the nature of the project or the material you are trying to communicate may limit your options. At this stage, you should experiment extensively, even varying the colors used within one word if this pleases you. You are the creative source of this piece of work, and you will find out what is possible only by attempting it.

You can create visual patterns with dabs of planned colors. View the words as a mosaic of marks and see what you can exploit from this framework.

Finally, make use of the space and tension within the design area and allow them to dictate somewhat the final size and proportion of the work.

Continue to explore the use of different-sized typefaces and even different typefaces.

BEMBO

uideatur, quae fuit umbra corporis,
dispereunt, quasi in ignem lana ti
umbras. Nec tamen hic oculos faili
sint lumina necne, umbraque quae
ratio discernere debet, nec poss
uehimur naui, fertur, cum stare
campique uidentur quos agimus
adsiduo sunt omnia motu, quandoq
pari ratione manere et luna uide
montis classibus inter quos liber
cursare columnae usque adeo liber
ruere omnia tecta minari. Iamque
quos tibi tum supra sol montis
sagittae, uix etiam cursus quinger
ingentibus oris, interiectaque sunt
digitum non altior unum, qui lapi
quantum caeli patet altus hiatus :
Denique ubi in medio nobis ecus
ferre uidetur uis et in aduersum t
nobis ratione uidentur. Porticus a

EXTRA

, cum permensa suo sunt caelum corpore claro Sol
i indicat ipsa. Exstantisque procul medio de gurgite
tis tamen ex his una uidetur. Atria uersari et circu
runt uerti, uix ut iam credere possint non supra sese
re alte cum coeptat natura supraque extollere monte
ingens feriudus igni, uix absunt nobis missus bis mil'
que iacent immania ponti aequora substrata aetheriis
etinent gentes et saecla ferarum. At conlectus aqu
despectum praebet sub terras inpete tanto, a terris
eare uidere corpora mirande sub terras abdita

imque oculos traiecimus.
tansque in perpetuum pari
gia coni, tecta solo iungen
is ortus in undis sol fit
er credas labefactari undic
quaecumque supra rorem
nt, refracta uidentur omnia
elum cum uenti nubila
·longe aliam in partem a
nsu fit ut uideantur omni
redis geminare supellex.
in summa corpus iacet om
frnere censemus solem
isire uidemur, et sonitus
allit propter opinatus ani
cernere apertas ab dubiis
possit, quoniam nil scire

nia ferri et fluere adsim
s suffuta columnis, longa
tque omnia dextera lae
uideatur obire et condere
e sensus. At maris ignaris
is edita pars est remorum.
onuerti sursumque sup
nt tempore nocturno, tum
ue <ra> ratione feruntur
quae tuimur fert tum bina
iplices hominum facies,
quiete, tum uigilare tamen
que diurnum, conclusaque
ire, seuera silentia noctis
quae uiolare fidem
ios addimus qui, pro uisis
imus quas ab se protinus
itetur. Hunc igitur

True-blue

a uidentur in statione, ea d
liber patet exitus ingens, ir
leo fit uti pueris uideantur, l
mque rubrum tremulis iubar
tis esse uidetur comminus
quingentos saepe ueruti ; int
e sunt terrarum milia multa
ui lapides inter sistit per s
iiatus ; nubila despicere et a
ecus acer obhaesit flumine et
rsum flumen contrudere rap

ius, propterea fit uti
ina fundunt, primaque
nigrasque sibi abluit
rum est ; eadem uero
nte, hoc animi demum
s adfingere noli. Qua
re ad puppim colles
uis cuncta uidentur, et

tant uitantque tueri ; sol et
irum grauiter simulacra feru
ecumque tuentur arquati, qu
, in eorum denique mixta, qua
quia, cum propior caliginis s
quasi purgat eos ac nigras
e poliens. Qui simul atque ui
ecuntur quae sita sunt in luce
osterior caliginis aer crassior
um rerum coniecta mouere
saepe rutundae, angulus opt

TRIANGLE

ncta firamina complet : absdique was ocularum
ocul turris cum cernimus urbis, propterea fit uti
cernitur omnis, siue etiam potius non cernitur ac
lura dum simulacra feruntur cogit hebescere eum
quasi ut ad tornum saxorum structa terantur : non
simulata uidemur. Vmbra uidet illam item nobis in sole
umine posse inducendi motus hominum gestumque
umbram perhibere suemus. Nimirum quia terra locis
eipetur item, quod liquimus eius, propterea fit uti
per enim noua se radiorum lumina fundunt, primaque
amne terra : et repetitur item nigrasque sibi abluit
o sit uis atque umbra figeri illorum est, · eadem uero
tius fiat pauio quod diximus ante, hoc animi demum
inde amici uidure hoc oculis adfingere noli. Qua
praeter reddixir ire. Et fugere ad puppim colles
essare aetheriis adfixa cauernis cuincta uidentur.
m permensa suo sunt caelum corpore claro bilque
dicar ipsa. Exstantisque procul medio de gurgite
amen ex his una uidetur. Atria uersari et circum

Delta-5

umbras. Nec tamen hic
sint lumina necne, umbr
ratio discernere debet.
uehimur naui, fertur,
campique uidentur quos
adsiduo sunt omnia mot
ratione manere et
montis classibus inter q
cursare columnae usqu
ruere omnia tecta minar
quos tibi tum supra sol
sagittae, uix etiam curs
ingentibus oris, interiect
digitum non altior unu
quantum caeli patet alt
Denique ubi in medio noi
uidetur uis et in a
nobis ratione uidentur. F
tamen parte ab summa
donec in obscurum con
lumen quippe ubi nil
in portu clauda uidentur
est, et recta sup
reuerti, et reflexa prope
splendida signa uidentu
At si forte oculo manu
tuendo

SHADE

r regione eadem nos usque secu
ahatur. Propterea facile et sp
concedimus hilum. Nam quocum
fuit hic eadem nunc transeat illu
m oculi naturam noscere nequ
uidetur ; quae manet in statio
aeter nauem uelisque uolamus.
udem longos obitus exorta uid
ntur in statione, ea que ferri
patet exitus ingens, insula con
uti pueris uideantur, ubi ipsi d
rubrum tremulis iubar ignibus
ise uidetur comminus ipse suo
terrarum milia multa que
des inter sistit per strata
nubila despicere et caelum ut
ter obhaesit flumine et in rapidas
lumen contrudere raptim, et
quali quamuis est denique duci
uidetur, paulatim trahit angusti
acumen. In pelago nautis ex
quam caelumque tuentur, ne t
lustris fractis obniter undae
na ; quae demersa liquorem
o fluitare liquore. Raraque per
suersum nimbos atque ire
ita supter pressit eum, quodam
lumina flammis, binaque per rect
leuinxit membra sopore somnu
temur, et in noctis caligine cae
is mutare. et campos pedibus

B ringing type and illustration together

The freedom of combining type and illustration lies in the ability to control both visual effects, allowing them to evolve together in a complementary fashion. The beauty is that, at the early stage of the design, one can predict the style, shape, colors, and size of not only the illustration but also the text. You can consider them both as separate elements, allowing each to make its own stand. You can integrate the illustration into the text by controlling its shape and color, or you can plan to overlay or integrate the text into the illustration.

How do you define illustrations? These are the drawn or painted elements of your design which are either commissioned or produced as original ideas by yourself. The form in whch they are going to appear is for you to decide, and your choice is infinite.

To experiment with these elements I suggest that you find some illustrations you like in a magazine or journal. Cut these out and use them as the basis for your design. Naturally, you can alter any element you wish, changing the color, shape, and size. The next thing for you to do is to practice applying headings and text. This can be quite simply done, using the knowledge you have already gained. There is no magic formula; it relies on excellent use of the space.

Explore cutting the illustration into segments, dividing up the text to fit the shapes of the illustrations. Allow the illustration to overlap the design space. Try all that is possible by producing small sketches first, and make use of the viewing device and possibly even of cut-out shapes.

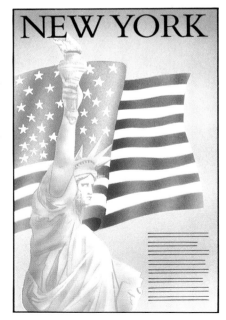

■ Airbrush

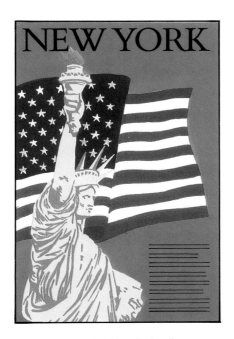

■ Flat color gouache without black outline.

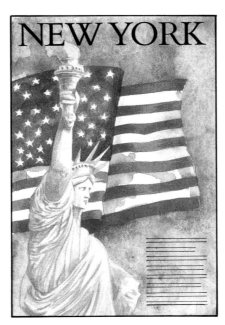

■ Watercolor

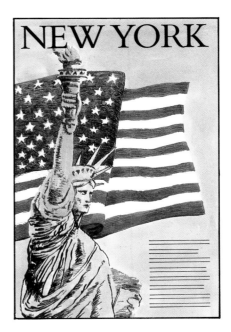

■ Black pen and ink with color.

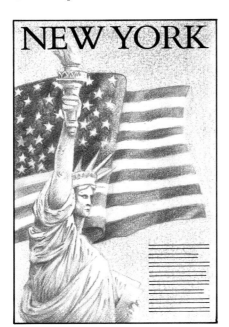

■ Colored crayon.

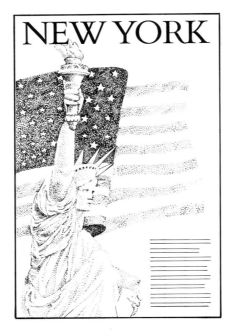

■ Black line dot and stipple.

■ The examples shown here are a good visual guide to how the same image can be made to look different, simply by using alternative techniques. You may wish to try other illustrations yourself to express the idea. As you can see, the final printed poster made use of the flag as its central theme.

B ringing type and photographs together

When producing a design with photographs, you need to adopt a slightly different approach from when you use illustrations. Photographs offer you another means of creative expression, but first you must know what is possible with your photograph. Normally, photographs are in full color or black and white and will be displayed in a straightforward geometric shape.

Nevertheless, there are some creative alternatives when using photographs. They can be cut out around the subject; they can be produced in a single color such as sepia; they can be vignetted, which means that the edges are softened so that the photograph disappears into the paper. Photographs will most often depict reality, which limits you slightly by requiring you to draw realistically or find suitable material in the initial stages of your design. I suggest that you find your examples in magazines or journals and build up a library of pictures, filed in various categories for future use.

The text and headings will be manipulated in the same way as you have done with illustrations. Often, though, some of the most attractive combinations of type and photographs are those that are kept sparing and rather formal. If you are using color on your type it may perhaps be better to limit the color in your photographs and vice versa. Try experimenting with the photographs you have found. It does not matter if you make mistakes at first, for there is an endless supply of visual material. For the sake of consistency in your design, you may be able to imitate the appearance of a photograph with a black and white or color sketch, adding the type to this to give the overall effect of your design.

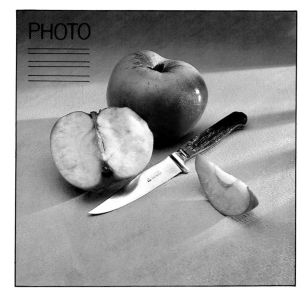

■ Light sources are mixed for a 'sunny' effect.

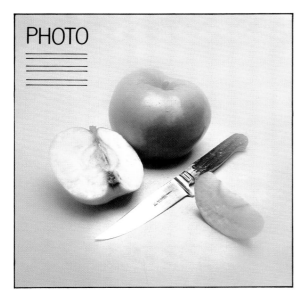

PHOTO

Soft light is used for 'soft focus'.

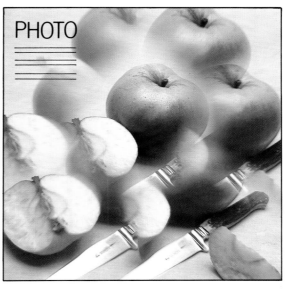

PHOTO

On these pages you can see just a few of the ways in which the same subject can be made to look very different simply by changing the lighting on the objects or by varying the technique used when photographing.

A multi-image photograph using a split prism multi-image lens.

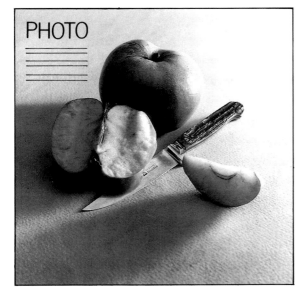

PHOTO

A standard black and white photograph.

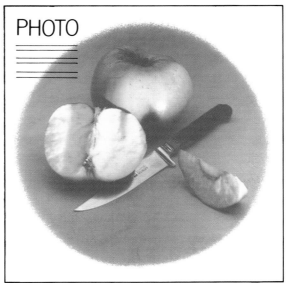

PHOTO

This black and white photograph is sepia-toned and vignetted.

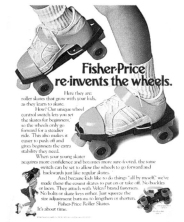

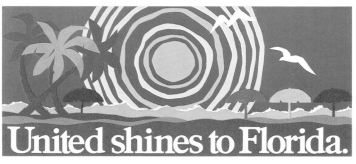

■ From these three illustrations you will have some idea of how this section develops into the use of actual headings related to photographs and illustrations. You will discover the sensitive balance necessary in relating text to visual matter.

THE VARIOUS AREAS OF DESIGN

The purpose of graphic design material is to communicate ideas, messages, visual statements and, occasionally, pure aesthetics. Most design work is specifically geared to the sale or promotion of the product or service it is projecting, and at present the industry is developing rapidly because competition among the manufacturers of goods and suppliers of services is increasing.

Each individual organization is attempting to establish a unique image and to promote its goods or services in an original but effective form to communicate with its intended market. The research that goes into deciding the characteristics of the market will also influence the graphic approach to the form in which the design material is presented. This research will also clarify the medium for which the work is intended.

The form the graphic work will take could fall into many categories. First, most organizations require an "image". This would normally be projected through their stationery, and it may even influence the style and format of internal documents. If the company manufactures products, these will need to be packaged, and the packaging will be influenced by graphic images. Even the delivery trucks will be styled to be in keeping with the overall image.

If it is a service company, or perhaps a publisher, it will handle book covers, magazines or brochures, which all have to be designed, whereas restaurants and shops require menus, pricelists and shop-front designs. And if a company decides to have a stand at an exhibition, the graphic content of the stand has to be designed. These are just some of the areas in which graphics are used, but possibly the largest single area, and the one that offers the greatest scope for ideas, is advertising. It covers posters, newspaper and magazine advertisements, promotional material, which will come in the form of showcards and point-of-sale displays, direct mail leaflets, and, finally, the glamorous area of TV and film.

In the following pages I will show some examples of these areas of work, together with some of the finished pieces, which you can analyze and assess the decisions that have to be made.

MAKING A FINAL DECISION

The decision a designer arrives at is always subjective. There is never a right or wrong decision, only the one that works for the subject, the client, and your own creative judgment. There will always be alternatives, which is why you should always present more than one idea for any single job. I suggest that you always produce a range of solutions and present them to the same high standard.

D esign and composition

Sometimes, when you are struggling with a piece of design work, it can be helpful to apply some rules to the organization of the various elements. Although this will not guarantee a perfect arrangement, it will give you a framework in which to operate.

Two main definitions that are commonly applied to composition in fine art can also be applied to design. First, composition is the arrangement of various elements to express a feeling decoratively. Second, composition is an arrangement of these elements to create a satisfactory whole, giving balance, perfect weight, and poise to those elements.

The design may often have to be arranged within a rigid framework, especially when it involves a great deal of text. This can be achieved by drawing a series of equal columns, known as a grid,

which will give you the framework for your text. Beware, however, of thinking too symmetrically, for the design can easily become predictable and dull. You can always introduce interesting subtleties into a formal design space to make a more dynamic image. Other aspects of composition you should consider are the balance of color within the design area and the depth that can be introduced to give the whole design a third dimension.

Finally, the use of a viewing device, or two interlocking L-sections, can often help you in your compositional decisions.

In the following pages pay special attention to the way the designs have been arranged; by isolating the use of the formal shapes in conjunction with the other elements you should begin to see some of the patterns of construction involved in effective design.

■ **Below** The illustration shows a formal, measured layout of type as set on a typical page. This is a five-column setting, but the page could easily have been divided into more or fewer columns. This form of layout is known as a grid. Although the grid is formal, the order can be interrupted with graphic devices, photographs or illustration.

A Tint band for first letter of heading
B Base line for heading
C Base line of first line of text
D Central gutter
E First column of five-column grid
F Actual page size
G Tint band for folio
H Base line for folio
I Type area
J Trimmed page size
K Base line for Running Head
L Text line numbers

THE GOLDEN MEAN

For centuries artists have struggled to find a formula for the perfect division of the picture or design area. Vitruvius, the Roman authority on architecture, devised the method known as the Golden Mean — sometimes referred to as the Golden Section. Realizing that there was a need to divide up space into equal sections to arrive at a pleasing aesthetic effect, he developed a system of mathematical calculation of picture division. Although the calculation itself is fairly complex, it is based on the general principle of viewing a rectangular space as being roughly divided into thirds both vertically and horizontally. By placing the main elements of your design on one of these lines, you will become aware of the balance created between those elements and the rest of your design. For example, if your design incorporated a picture of a church, you might use the spire as the focal point, placing it so that it appeared exactly on one of the two vertical dividing lines. The rest of the picture area would then relate back to this dominant element.

You will see this for yourself by studying some of the designs shown in this book.

■ **Left** This book cover for *The Cavalry* (published by Purnell Book Services Ltd, 1976) makes obvious use of the Golden Mean.

■ With a ruler, draw a line AB. Divide this into two equal lengths. Place a compass point on B and draw a ¼ circle to find point C.

■ Draw a line from A to C and with the compass point on C draw an arc from B to meet line AC and to create point D.

■ Place the compass point on point A and draw an arc from D down to AB to create point E.

■ This exercise will help you quickly to establish a method of dividing up the design or picture area into the sections known as the Golden Mean. With a ruler and compass, any length of line can be divided into the proportions of the Golden Mean.

■ You have now divided AB into the proportions of the Golden mean. Continue these divisions to divide the picture plane both horizontally and vertically, thus giving you the proportions to help with the composition of your design.

D eciding on the size and shape to work on

CHECKLIST

■ Consider the medium for your design.

■ Consider the purpose of the design.

■ Seek out the restrictions governing the size of your design.

■ Remember that the shape of your design can be controlled by the design process.

■ Avoid awkward shapes.

■ Try to keep your paper sizes economic.

Whenever you are faced with a design brief, it will normally include the medium for which the design is intended. It is safe to assume that if you know the purpose of the design and the medium in which it will appear, the parameters influencing the shape and size of the finished work will be apparent.

There will also be rules governing the sizes of specific projects. For example, if you are designing a poster, you will naturally have to consider where it is going to be displayed and whether there is a set format for the size of the work. The same will apply to advertisements that are bought according to size, packaging that has to accommodate its product comfortably, brochures or stationery that have to fit into standard-sized envelopes, and books that need to be displayed on standard book-shelves. So you can see from this list that there are going to be some elementary restrictions governing the size you work to.

The shape of your design poses further problems, most of which can be controlled within the creative process. For example, if you wish to use an unusual shape for your book or brochure this will have to be achieved by the cunning control of the central area of vision. It may be impractical to create, say, a circular-shaped book, but by using optical devices, you can imply this shape in the way you present your design. In other words, you can create shapes within shapes.

There are also a few financial factors governing shape. Unusually curved cuts or impractical shapes are expensive to produce; similarly the uneconomic division of paper sizes can be expensive since it causes unnecessary waste.

■ This design is a good example of how a shape can be changed optically by placing a shape within a shape.

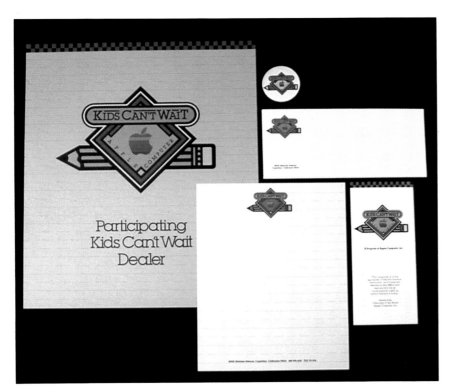

Left The distinctive graphics in these designs overshadow the paper size by being very bold and punchy.

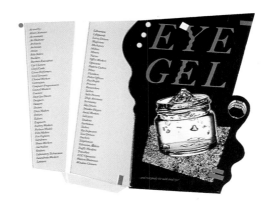

■ **Above** In this piece of work you can see the versatile way in which interesting shapes are combined to form a three-dimensional show card.

■ **Left** It is sometimes possible to create something out of the ordinary, and the shape of this book illustrates the freedoms you should explore.

D eciding on the position of one heading

Now you will be analyzing actual examples of graphics and assessing the conclusions and decisions to be made within the design process. As previously stated, there is no right or wrong decision; there is only the one that is acceptable and that works. In the example on this page, the designer had to make a decision regarding the cultural, visual nature of the subject or product and also consider the desire of the company itself to communicate. In the poster you can see that simple, modest typography, used in a fashion that imitates the space and tension of ancient Japanese prints, achieves a natural sympathy with the climate, culture, and country.

Clearly, with such good visual material, the heading need not dominate the space, for the picture itself encourages you to find out more. This particular example plays very much on the aesthetic interplay of horizontal and vertical tensions.

There are numerous alternative options open to the designer, many of which are perfectly valid but would offer a different way of solving the problem. It is up to you to find the solution that you feel resolves the problem to the best advantage.

In addition to the poster, a number of alternatives are shown. Study these, making a mental note of the subtleties and aesthetic arrangements that work for you. Never lose sight of the main factor: the design must relay a commercial message.

Now try some alternatives for yourself, improving on the ideas shown here.

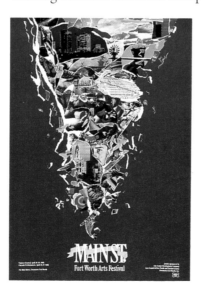

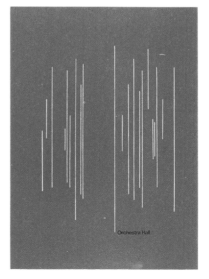

■ **Left and far left** These posters make dramatic use of space, with a single heading positioned almost as a signature or symbol of the space itself.

Right In this design the large blow up of the flower dominates the entire picture area, allowing the words to be displayed almost affectionately, and to complement the picture area.

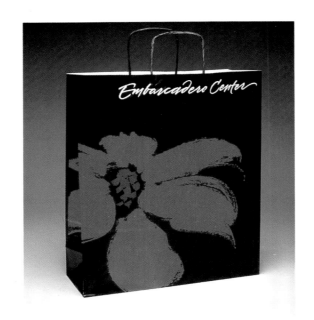

Below This formal design series relies on a strict and regular pattern in which the headings are displayed in precisely the same position on each package; this gives a corporate identity to the product range.

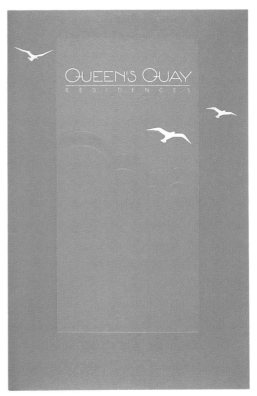

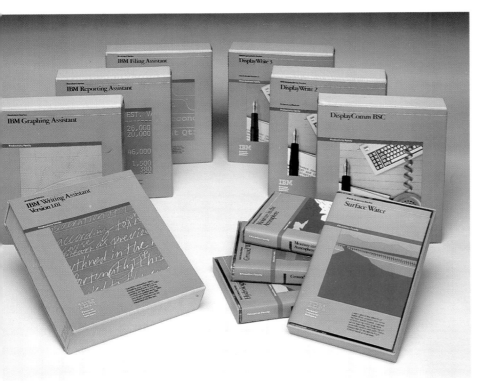

Above This piece of work elegantly echoes the designs of the past, making use of geometric patterns, and a simple color combination, carefully spaced on textured paper. The central panel has been embossed on a lighter, printed green panel. This shows extravagant use of both materials and print methods.

D eciding on the position of two headings

CHECKLIST

- Choose some different typefaces.
- Balance the weight and size.
- Arrange these, making different shapes.
- Invent some methods of division.
- Think of a heading as an illustrative element.
- Think of some alternative designs.
- Make some thumbnail sketches.

When the main element of the design revolves around two headings or statements, the problem is to decide which of them requires greater prominence. Naturally, one wishes to make the most interesting and effective design, but a decision has to be made as to which, if either, of the headings needs the more prominent position.

The next consideration will be the space that the words are going to occupy and also the style and image that the subject is intended to communicate.

By comparing different typefaces, sizes, and weights you will be balancing these elements visually, at first by trying to make these decisions in your head. When you discover an arrangement that you think may work, you will need to sketch this for further development.

Looking at the series of paperbacks on this page, you can see that the visual balance of the words is separated by several devices. The first and most obvious is the change of weight of the typeface to give greater emphasis to one aspect of the information. Second, the horizontal lines act as a graphic divider, separating the headings. This also, incidentally, is used as a unifying element to connect the designs in a house style.

The next aspect of these designs is the way the type is applied. Each element has been centered

■ The headings here have been proportioned to give shape and weight to the visual material. Your eye is automatically brought down from the main heading to the central image by means of a triangular device so that you receive the visual and written message simultaneously.

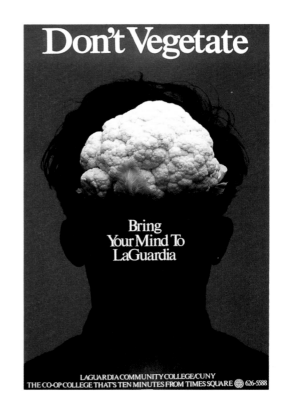

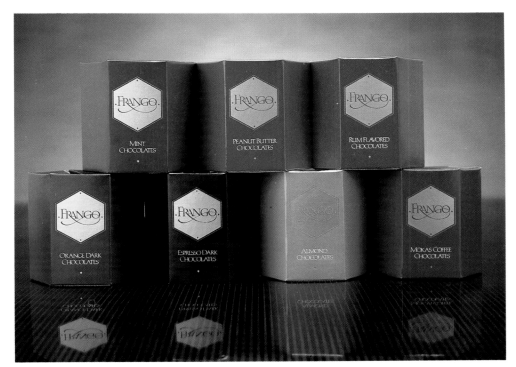

■ **Left** These coordinated packs keep the main heading constantly in focus while relying on the secondary heading to convey details of the contents. The company logo in its distinctive frame retains its predominance.

proportionally in its design space, thus allowing a feeling of freedom and air around these very formal shapes.

Finally, the overall impression is one of graphic shapes and weights, not merely of words.

The other example shown here makes use of both texture and three-dimensional space. The main heading dominates the design area and forms a vertical, rectangular illustration that merges with its surface, while the second heading almost floats above the surface, separating itself from the main title. This is another way of viewing the design space and one in which the two levels are deliberately used to create tension in visual depth.

By the use either of pure type or of type manipulated to become an illustrative element, which would have to be drawn or photographed, you have alternatives in creating your design.

■ **Above** The two headings displayed in this advertisement set up a tension that leads you diagonally across the area from top to bottom.

■ **Left** This poster combines illustrated lettering, which shouts the main message, with a more serene description, presented very graphically in the squared-off formula, in the bottom right-hand corner.

P ositioning multiple headings

CHECKLIST

■ Determine the size and proportion of your lettering.

■ Try a number of compositions.

■ Introduce color.

■ Introduce the other elements.

■ Experiment with the size and position of these elements.

■ Introduce color to these elements.

■ Study the alternatives shown here.

■ Compare your own choice with the printed design.

When you are faced with the prospect of communicating a lot of information of more or less equal importance, you will find certain restrictions. First, how large does the wording need to be? How much of the design space will it occupy? How do you lift elements out of this working without disrupting the harmony of the layout? Finally, how do you create a design that puts over the nature of the subject with feeling and sensitivity for the product or service?

Your initial decision will be to determine the size and proportion of your lettering. This will determine how much of the space you have left. Your next option is to try some alternative layouts or compositions. You can then alternate the weight and feelings generated by the space with the subtle application of color. When you are satisfied that the main areas of type are established, you can consider the other elements. In the case of the conference poster shown on this page, a formal block of type has been created, which occupies about two thirds of the space. The weight of this has been softened with light, spacious type, and subdued shades. The final line of this type, projecting the theme, is lifted skillfully off the surface by the use of another color. The leaf shape, occupying the lower part, acts as a natural textured contrast to the classical, sculptured lettering. This is finally held in balance with a line of smaller type, significant in that it occupies its own territory in the design area.

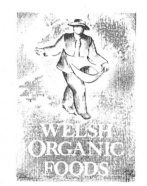

This example deliberately uses wide spacing between the headings to give a period feeling to the message conveyed.

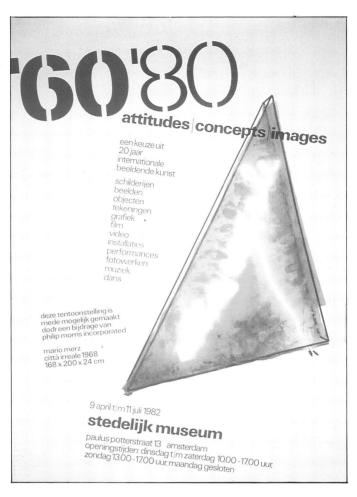

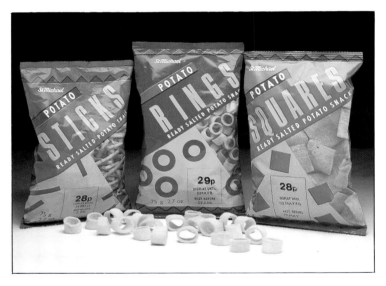

■ **Above** These packs give a busy, rhythmic impression, and the style of headings, with wide spacing, supports this.

■ **Above** The poster uses multiple headings to echo the angular shape of the illustration, deliberately breaking any rules of established formal design.

■ **Right** In this brochure the image conveyed is very formal, giving a feeling of institutional stability. However, the message has been deliberately obscured to force the reader to investigate further.

P ositioning a heading with a photograph

When combining a photograph with a heading or headings, you will have to unite the headings and photograph in some way. For example, the heading may describe the elements of the photograph, or it may reinforce the statement being made by the photograph. Here you will be looking for a visual balance and link between both words and picture. While considering the best way to display these elements, you may wish the headings to occupy a separate space from the photographs. On the other hand, you may wish to unite words and picture by

printing your lettering over the top of the image or by reversing it out, leaving visible the surface on which it is printed.

The examples on these pages have made use of some of these alternative approaches.

To experiment for yourself, try finding some interesting pictures, invent a heading or two, and, using the overlay method described earlier, play around with the positions of these elements. Look for the various ways you can either subtly or dynamically interlink type with your photograph.

Right The headings here are integrated with the photograph, linking the image to the message.

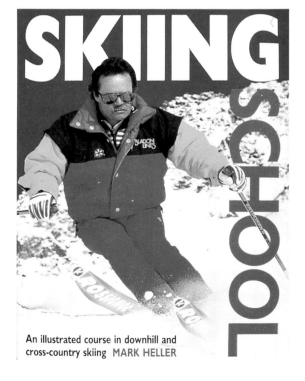

An illustrated course in downhill and cross-country skiing MARK HELLER

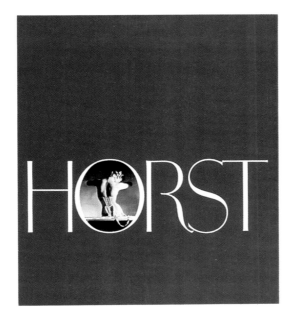

Below These packages display their contents in a minimal but attractive photographic style. The headings use the background of the photograph, reversing the message white out of black.

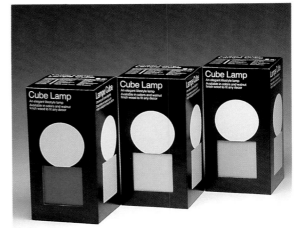

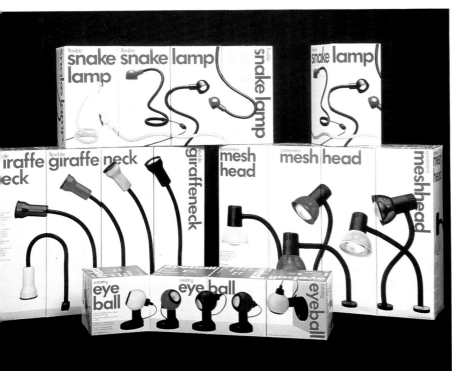

Left The versatility of the product is described in two ways. First, by the way in which the items are portrayed around the invidiual packs, and second by the way in which the packs link together. The flexibility of the product is established by the solid strength of the headings.

P ositioning headings with photographs

There will come a time when you have more than one photographic image to place in the same space as your headings.

This can be approached in many different ways. First, there is the formal separation of photographs and headings and the dividing up of the design area in equally balanced shapes, perhaps even by applying the rules we discussed in the pages on composition. Next, there is the informal approach, which allows the images to dictate the direction and shape. These may even be overlaid, so that they are placed over one another to form collage arrangements. While thinking of the photographic content, you should be considering how best to approach the headings. Again, you may wish them to remain formal in a conventional layout, while the photographs are cut or positioned in dynamic and exciting ways.

Alternatively, the photographs may be formally positioned while the words are arranged either by overlaying them on the picture or by arranging them outside the picture area in a variety of opposing angles.

The most important consideration will be the way you communicate the images for the subject. The examples here, together with the various alternatives, explore the most effective design solutions.

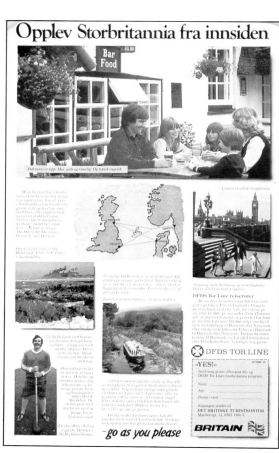

■ The design here, although based on a formal grid for the initial type, diverges from the strict, rectangular shapes by introducing shadowed, cut-out images and loosely dropped-in visual matter.

Right The background photography with its montage of images, reflects a view of the life in Chicago. The heading is integrated extravagantly across the top of the photograph in a sophisticated style.

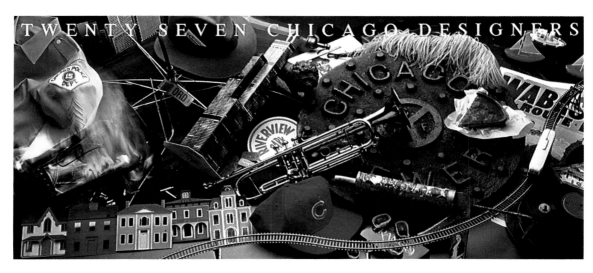

Above When many photographs have to be displayed, a pattern or formula needs to be employed. In the case of this book jacket, the numerous photographs occupy the outer perimeter in equal proportions, leaving a large central area in which the type may be displayed.

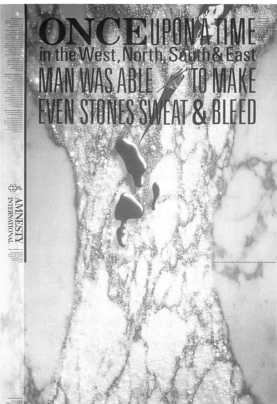

Left This abstract photographic image symbolizes the struggle while cunningly acting as a light-textured background, that allows the text to be overlaid in black. Note the vertical strokes of the typography, which reflect the downward pull of the overall image.

Mixing headings and illustrations

One of a series of posters, showing clearly how colorful, loose illustrative images can be incorporated with bold established typefaces.

Illustrations and headings possibly offer more creative freedom in the design process than is sometimes found with photographs. This is because you not only will be in control of the shapes and sizes created by the words but will also have the same control over the illustrations. These can be made to occupy whatever shape or size you wish to allocate to them. You can also look for an appropriate technique, style, and image, often with the view of later employing a suitable illustrator to create the right effect.

The best way to discover the types of illustration being produced is to study those magazines and books in which they appear. Make a collection of work for use as reference material.

In the meantime, to get a feel for the possibilities, I suggest that you imitate the style or styles that you may wish to use in your design. You may even use the examples you have found as the means of creating some early layout ideas.

Remember, though, that the word illustration can be applied to the most formal image as well as to the loosest brush stroke. The range of possibilities is infinite.

With regard to headings, here again the freedom or restraint you experience when combining type with illustrations is entirely your own choice. However, there are a great many more opportunities for experimentation when using illustrations.

Try placing the illustrations in cut-out shapes and moving them around the design area. Enlarge and reduce them. Try them in a single color and in many colors. Use different-textured surfaces and different drawing instruments, and experiment in the same way with your headings.

The illustrations shown here, with the alternative layouts, should give you some notion of how to manipulate the elements. Do not allow the experimentation to end here, but try designing some layouts for yourself.

Trackin' Field Mice

1984 CAT GAMES

Petromalt The Official Hairball Remedy of the 1984 Cat Games.

Left The typography in this image not only echoes the style and period displayed by the illustration, but also evokes the feeling of a swishing saber in the large C, which acts as a link between heading, subheading and illustration.

Above The quasi-medieval illustration, combined with the vibrant interplay of this two-color image, forces your eye to the formal typography displayed in the off-central white panel.

Left The most prominent image in this book jacket is, quite obviously, the author's name, although the linking of the illustration as a solid silhouette acts as a good background to the more realistic objects in the foreground. One is left with an impression of the author while all the other information pivots from a central point running vertically through the book.

P ositioning headings around a free shape

■ The illustration in this advertisement is deliberately exaggerated to fill the design area diagonally in a bold and dynamic way, leaving space top left for the message and bottom right for the location.

Many creative situations will involve the combination of a graphic shape with a heading or headings. The shape may be as simple as an abstract mark or as complex and/or realistic as a photograph.

Whatever this graphic element is, it will have to be viewed initially as a solid, negative shape. What I mean by this is that you should view the outline of the free shape and use the area around your shape to control the design. The example of the giraffe's head and neck shows how the shape can be used to divide up the design area. The nature of the shape has allowed the designer an opportunity to split up his picture area diagonally, leaving him with two triangular areas, top left and bottom right, in which to arrange his headings.

Other examples of this will emerge when you place a heading with a company logo or symbols devised out of free shapes.

Free shapes can be created from any images that appear to you, simply by viewing them as negative shapes. Once you have done this, they can be presented as illustrations, photographs, line drawings, woodcuts and in numerous other forms. The important thing is to arrange them within the design area so that they present the viewer with the right concept for the design brief.

It is possible either to use conventional methods of composition or deliberately to flout them.

The positioning and typeface of headings will be very influential in the power and importance of the shape.

Below The free-shape illustration in this music program expands out of the central space to tease the heading, which also carries its own inventiveness in the way the letter forms have been displayed. Note, that although this is produced in just two printed colors, it remains effective and stylish.

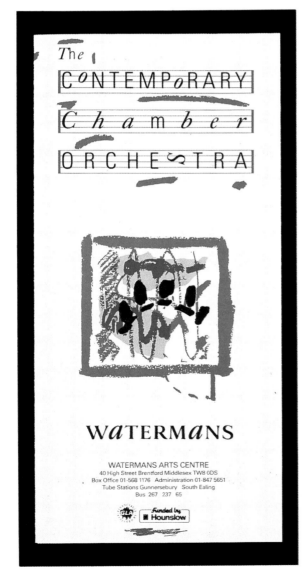

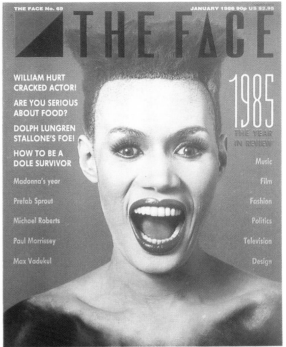

Left The head, being the central feature of the front cover of the magazine, is surrounded by the contents of the publication. By using a mid-tone background it has been possible both to reverse out type and to overprint in black.

Right The shape used as the main, central illustration for this book jacket has been designed intentionally to incorporate the title.

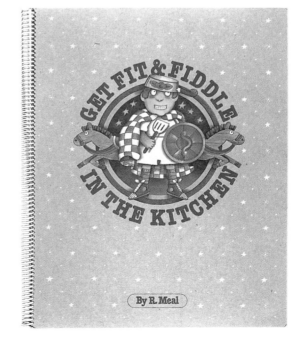

P ositioning headings and text with rectangular shapes

Bold type serves to emphasize the geometric shape of the photograph, and the hardness and sharpness of the design exaggerate the softness and irregular shape of the photographic image. Interestingly enough, the minimal text has to be searched for, but it deliberately conveys a more modest stance than the extrovert message.

You are now faced with the problem of positioning a rectangular shape within your design area and, separately, a heading or headings and text, and you should carefully assess which of the elements will occupy the most dominant space. There may be restrictions that will affect the domination of any particular element. For instance, the text may be so extensive that it requires a great deal of design space and quite a large type size to make it readable. On the other hand, the strength of the message being communicated could be visual, leaving the text and headings as secondary elements. Finally, an equal balance can be struck between both text and rectangular shape. I am assuming that the rectangular shape will, generally, be a photograph, but you must accept that it could be any form of graphics.

There are many ways of balancing these elements. As a guideline, consider dividing your design area into thirds, and experiment with one-third picture and two-thirds text and vice versa. Try setting the text in columns, using a grid, and offer a variety of rectangular shapes to this formal arrangement. You will notice that many press advertisements running over two pages of a publication often use one page to present the visual aspect of the message, while the headings and text appear on the remaining page. There are many interesting formulas to conjure with, but always allow the texture, tension, and perhaps the color to determine visually the stress of the design area. Produce many alternatives, allowing your creative eye to assess and evaluate the result.

Simple instructions for changing your spare tire.

Join the YMCA.

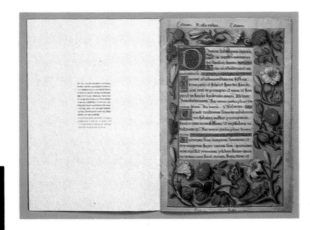

Left Photographs do not always have to be used to fill all the design area. Here the photograph occupies a measured space of its own, while the main text takes on its own space and page. The copy alongside the photograph has been placed there with reverence and respect.

Left Here, the rectangular shapes in the margins set a theme for the double-page spread. You can see that the structure of the main type is also set in rectangular shapes. Everything on these pages suggests formal, traditional order.

Above The main illustration on the right-hand page shows a border surrounding a rectangular panel of text. The left-hand page of modern text is designed sympathetically to echo the medieval formula. To avoid overpowering its neighbour, the modern text has been created on a smaller scale, with a wide border.

Mixing headings and text around free shapes

CHECKLIST

- Make some geometric shapes with your text.
- Apply your shapes to cut into your text.
- Try different weights of text.
- Try different emphasis of shape.
- Try different proportions for text.
- Try different proportions for shapes.
- Decide on the most successful layouts.

By varying the size of the image that is placed in the design area, you will be left with the space for the copy, which can then run around the shapes while at the same time linking them across the area.

The options available when mixing the informal and the formal are both exciting and numerous. It is at this point that you can allow the restraint of confined areas of design to be disrupted by dynamically placed images. The first problem is to choose the alternatives within the design area for your headings and text. Once you have confidently established a rigid structure you can set about injecting irregular and possibly volatile images to cut through the symmetry. The decisions you now face are concerned with the image you are trying to create and its relevance to a practical design brief.

This approach to design is useful when considering information that may otherwise be projected in an unexciting and uninspired manner. What I am doing is stimulating your visual faculties by introducing dynamic pauses to what would otherwise be tedious reading matter. The shapes themselves act as controlled interludes that help to support the text.

Mixing text and free shapes can eventually pose some technical problems, since your text layout and length will have to be calculated to form a shape consistent with the negative shapes left by the visual images. To investigate ways of solving these problems, cut out, from a magazine, some text that is printed in columns and find some interestingly-shaped illustrations. Disregard the content of the text but cut the words around the shape of the chosen illustrations to see the line produced by these elements.

The technical term for text that runs around a shape is simply a "run around." Try a variety of options for yourself.

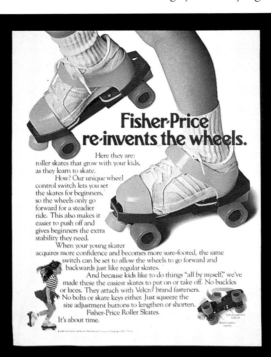

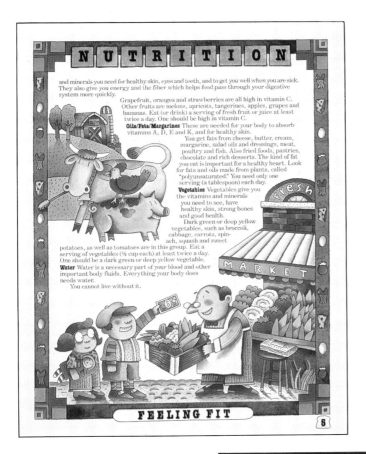

Left The theme of this design is based on playing cards. The central free-shape image has supporting text above, and when it is turned upside down, the layout is repeated with an opposite image.

Above Illustrations give greater freedom in the creation of free shapes, and, as you can see from this example, the border and main characters determine the flow of the text.

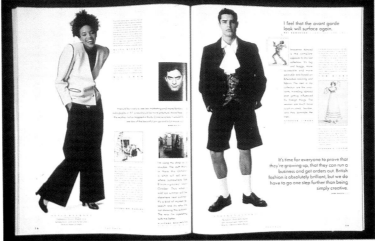

Left Whatever size you want your photographs to be, it is possible to make the copy work around them. In this double-page spread, the main images have taken priority, and the text and supporting illustrations play a secondary role.

Mixing headings and text with illustrations and photographs

CHECKLIST

- Consider the media for which the design is intended.
- Mark out your design area.
- Position your photographs within the design area.
- Create some structured columns for your text.
- Produce a variety of options.
- Introduce some illustrative shapes.
- Use color to emphasize particular elements.
- Counter-balance and coordinate the colors.
- Vary the proportions of the elements.
- Use the text to separate the illustrative/ photographic elements.
- Study the examples for guidance.

The balance between photographic and illustrative images has several technical limitations. A photograph will probably need to occupy its own regularly shaped space, whereas an illustration can be produced without these restraints. The important consideration is how to display these without giving a messy, unnatural feeling to the design.

The photographs you use will probably be rectangular and will demand a formal and structured layout. The illustrations, however, and maybe even the typography, could be viewed as irregular shapes, and you should use these more pliable elements to make interesting patterns. For example, take your photograph and position it anywhere within the design area. Then produce some regular columns to represent the areas for text. With a heavier instrument, mold these into interesting flowing patterns, injecting the occasional irregular shape, which could easily be the basis of illustrative creations.

At this point, you may wish to consider introducing color to the form. The photograph will most probably be in full color, but why not consider reproducing it in a single color or tone? You should counter-balance tensions and harmony between photographic and illustrative elements. Occasionally the text may demand prominence. This can be achieved by color control and coordination; but do not overplay the use of color in

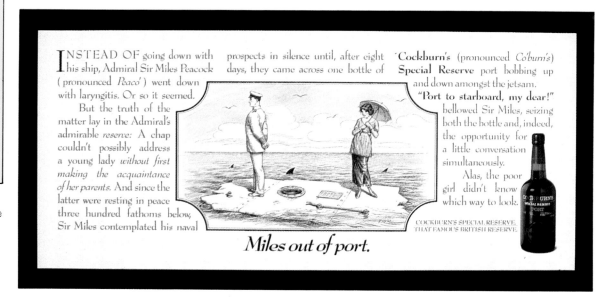

This old-fashioned looking illustration is very much part of the old-style lettering surrounding the image. Both combine to emphasize the tradition and quality of the product, which cleverly occupies the final phase of the advertisement.

Right In this piece of work the main theme is surrounded by an illustrative border. The text and photographs within the borders have been arranged around an underlying grid.

body text as it can become disjointed and un-balanced. Use the blackness of the text to structure the degrees of color used in the other elements.

In the following pages you can see that a great number of pieces of design work require the support of text and photographs and the creation of illustrative or graphic elements. Nearly every form and approach will require its own identity to convey the perceived message.

In the end, successful design is the use of shape and form to achieve the right balance of all the elements involved. For example, if you are designing a poster you must consider its potential to be ignored, and you should, therefore, emphasize its most stimulating element. On the other hand, a menu or magazine page may require less obvious impact, subtly enticing the reader to become involved. The examples on the following pages show just a few of the areas that are likely to present you with the combination of elements we have discussed.

Left The illustrative device used at the top of the page seems to connect with the blocks of text to give the impression of a threatening bomb. The random design of the illustration is formalised by the staid columns of regular copy.

continued overleaf

Right The photographs break up the formality of the columns of type with a burst of color and energy, which leads from the foot of the page and allows the main heading to be placed at the end of the spread.

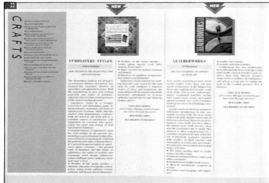

Above This example shows how a block of solid color can act in an illustrative manner, either simply as decoration or to emphasize a main feature.

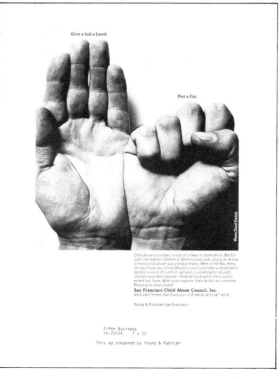

Left This design makes use of the rectangular shape of the photograph, together with the free shapes created by the subjects. The extension to the right hand formed by the text is equal in proportion to the space above and gives a diagonal thrust to the overall image.

Left The formula for this
spread evolves from the centered
heading and the illustration and
photographs below. The balance
of image and type on both sides
is equal and formal. However, the
angled photographs and copy
make the overall appearance
irregular and busy.

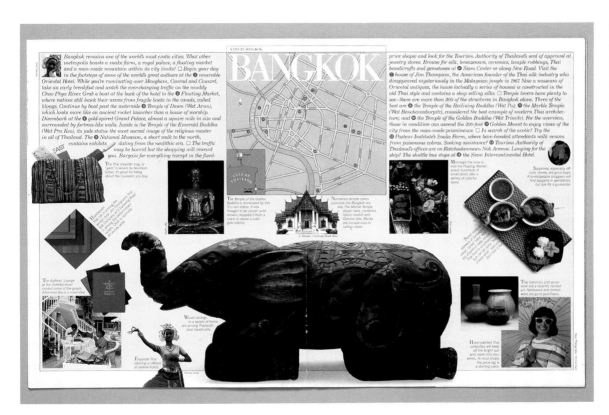

Right A simple design with a
sensitive use of background color
can produce some sophisticated
results. The example here uses a
marbled illustrative background to
support the atmosphere created in
the interiors. The classical and
simple lines of the text reflect this.

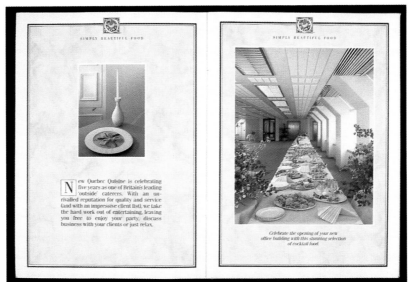

continued overleaf

Right If you are limited to black and white, you should look for different textural qualities. In this example a light space emphasizing the dense lines of the woodcut leads into the gray, formal display of text. The illustration in the centre is in line with the woodcut and links the two pages together.

Left This design is underpinned by the eight-column grid, which runs across the top of the page and the illustration of the tree and the main heading make full use of this basic grid. The other illustrations and photographs are able to float freely in the bottom half.

To shop in the open air, go Underground.

Left and below left These two posters use a six-column grid. The top one is more conventionally designed, with the illustrations used as copy breaks. The lower one uses the shape of the dinosaur to break up the design diagonally. Both are kept in style by using the same illustration source and typographic face.

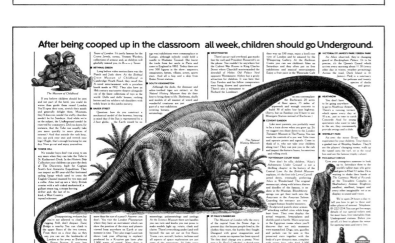

After being cooped up in the classroom all week, children should go Underground.

Right This page is based on a four-column grid, but two design factors make it very different: first, the heading that runs vertically along one column, and, secondly the body copy that is all reversed out of the color. The overall colorful, sporty impression is echoed in the photograph.

continued overleaf

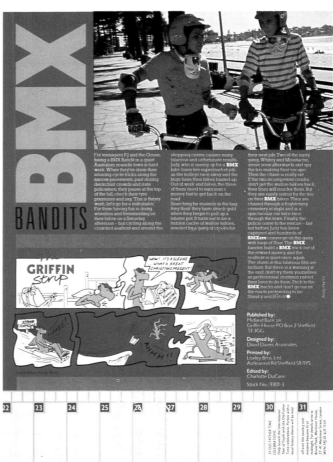

Although the design of this illustration is based on formal composition, it is very loose and artistic and has a delicate hand-rendered feeling.

The central theme of the fish is shown not only as a startling image but in bold lettering. The surrounding text grid is punctuated by the silhouette images of various fish, which echo the main theme.

■ Here is another good example of a four-column grid, broken up by free and regular shape images.

■ This double-page spread captures the flavor of the article by lightly reproducing an underlay of relevant, related images. Placing the text more formally over the surface, gives added dimension and interest to the pages.

Choosing a suitable typeface

You will now be aware that the styles of typeface used in design are extremely numerous. Over the centuries type has evolved from hand-formed letters developed from Roman lettering through the manufactured printers' type fonts, which are collections of alphabets and numerals in the same style. These in turn evolved from wooden, hand-cut letter forms, through metal type, to the present, when type is held in computer files. This is known as photo-setting as it is presented for print on thin, photographic paper.

When choosing the typeface or faces for your design, you will need to assess carefully the image you wish the type to convey. To understand this, compare a design presenting a nostalgic or old-fashioned product or concept, where the type used should convey a link with the past and project a comfortable, well-established image, with a design presenting a modern, possibly high-technology approach, where the type used is devoid of frills and projects a professional, controlled image.

It is important to remember that the typefaces of the past are just as available as those of today. Typefaces are never discarded, and new ones are frequently introduced. There are, however, distinct phases and fashions, especially in publicity, and old faces are given a new lease on life and become the everyday, popular images. Alternatively, a newly designed typeface may very quickly achieve great popularity. Become aware of current trends by seeking out the typefaces that seem to be in continual use in advertising and graphics.

There are a number of factors to bear in mind if you are considering mixing different styles of type in one design. For example, it is unlikely that a light, classical serif type will mix with a heavy, sans serif face. Also, as mentioned earlier, the style of face should be in keeping with the nature of the subject it communicates. You will discover those typefaces that work together and are appropriate to an image only by experimentation and visual comparisons. To find a reference source for type-

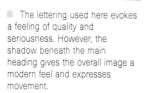

The lettering used here evokes a feeling of quality and seriousness. However, the shadow beneath the main heading gives the overall image a modern feel and expresses movement.

Left The typography chosen for this book obviously reflects its title. It has been produced with sensitivity and care taken with the various weights of typeface.

faces, contact your printers or typesetters, but also begin to build up your own library of typeface styles.

Examples of type used in designs should also be collected as reference material for the typefaces used in a range of contexts.

The specimens shown will reinforce this visual imagery, and the working sketches should give you some idea of good and bad alternatives.

Finally, it is now important that you begin to render type styles accurately and copy the forms precisely. Also pay special attention to the letter and word spacing, since this will also influence the overall image. Try rendering some selected type styles before working within the design space, looking particularly at the possible variations.

Right A totally different approach to typography is evident here. The complementary letter forms for the heading are carefully mixed, while various typographic weights are used in the body copy.

continued overleaf

Right The typeface used in this advertisement is popular today. It projects the right "image" for a large number of consumer goods, and it is bold, easily read and has a certain feel and style.

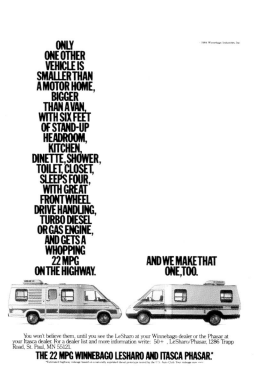

ONLY ONE OTHER VEHICLE IS SMALLER THAN A MOTOR HOME, BIGGER THAN A VAN, WITH SIX FEET OF STAND-UP HEADROOM, KITCHEN, DINETTE, SHOWER, TOILET, CLOSET, SLEEPS FOUR, WITH GREAT FRONT WHEEL DRIVE HANDLING, TURBO DIESEL OR GAS ENGINE, AND GETS A WHOPPING 22 MPG ON THE HIGHWAY.

AND WE MAKE THAT ONE, TOO.

You won't believe them, until you see the LeSharo at your Winnebago dealer or the Phasar at your Itasca dealer. For a dealer list and more information write: 50+ , LeSharo/Phasar, 1286 Trapp Road, St. Paul, MN 55121.

THE 22 MPG WINNEBAGO LESHARO AND ITASCA PHASAR.

Estimated highway mileage based on a naturally aspirated diesel protype tested by the U.S. Auto Club. Your mileage may vary.

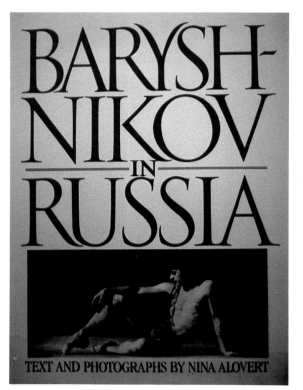

BARYSH-NIKOV IN RUSSIA

TEXT AND PHOTOGRAPHS BY NINA ALOVERT

Left This typeface conveys the flowing elegance of dance and at the same time suggests our preconceptions of Russia. Beware of overstating a national identity with type image.

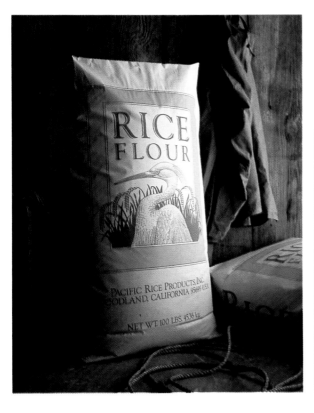

Left It is important that the typeface used projects the image or product in an appropriate and relevant way. Modern typefaces can be experimented with subtly to give a unique quality to your design. The example shown here retains both quality and individuality.

Above This design shows how delightfully good typography can enhance the simplest of packages.

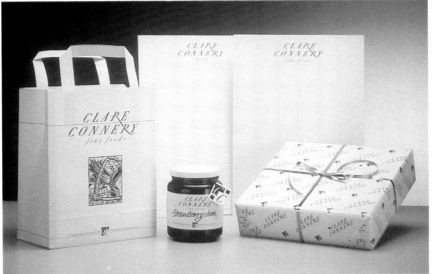

Left The typography used in packaging or product labeling needs to echo the image of the product. Here, a range of designs evoke an artistic, hand-made quality through setting a style by choosing the right typeface.

continued overleaf

THIS IS NOT DUMMY COPY. IT IS MEANT TO BE READ. IT IS NOT A SUBSTITUTE FOR THE FINAL COPY WHICH WILL BE INSERTED AT A LATER DATE, BUT THE ACTUAL COPY WHICH HAS BEEN WRITTEN SPECIFICALLY FOR THIS AD. THIS AD WAS SET BY PHOTO-LETTERING, INC. THAT'S RIGHT, WE SET TYPE! IN FACT, MANY PEOPLE DON'T REALIZE THAT PHOTO LETTERING, INC. HAS BEEN SETTING TEXT SINCE THE LATE 60'S. OVER THE LAST FOURTEEN YEARS WE HAVE UPGRADED AND GREATLY EXPANDED OUR TEXT SETTING FACILITIES AND CAPABILITIES. NOW, WITH AN EVER-GROWING LIBRARY OF OVER 700 TEXT FACES INCLUDING EVERY ITC TEXT FACE, WE ARE SETTING COMPLETE ADS. (WE HAVE BEEN FOR YEARS!) WE ALSO DO COMPLETE MECHANICALS OF ADS—HEADLINES, TEXT SETTING, CLIENT'S ART, ETC. WE'VE REALIZED THAT FOR MANY YEARS WE HAVE BEEN KNOWN FOR OUR HEADLINES, PHOTO-EFFECTS, AND EVEN OUR SPECTRAKROME "ONE-OF-A-KIND" COLOR PREVIEW PRINT PROCESS; AND WE ARE PROUD OF THAT REPUTATION. SOME OF OUR SPECIAL PHOTO-EFFECTS ARE UNPARALLELED ANYWHERE IN THE WORLD. BUT EQUALLY IMPORTANT TO US IS THE FAST GROWING KNOWLEDGE THAT PHOTO-LETTERING, INC. IS A COMPETITIVE "TYPOGRAPHER" WITH COMPETITIVE TEXT SETTING FOR ALL OF YOUR TEXT COMPOSITION NEEDS. THIS IS NOT DUMMY COPY. IT IS MEANT TO BE READ. IT IS NOT A SUBSTITUTE FOR THE FINAL COPY WHICH WILL BE INSERTED AT A LATER DATE, BUT THE ACTUAL COPY WHICH HAS BEEN WRITTEN SPECIFICALLY FOR THIS AD. THIS AD WAS TYPESET BY PHOTO-LETTERING, INC., YOUR ONE STOP, FULL SERVICE TYPOGRAPHER. 216 EAST 45TH STREET, NEW YORK CITY, NEW YORK 10017. TELEPHONE 212-490-2345.

SIMPLY BEAUTIFUL FOOD

Smoked French maize-fed chicken

Californian chicken

Chicken filled with fresh crab mousse

Poached chicken fanned on a spinach coulis

Smoked chicken, avocado, bacon and croûtons on a bed of endive

Strips of chicken and mango with a fresh lime and ginger dressing

Chicken Iberia (strips of chicken in a fresh coriander, lemon and olive oil dressing with julienned carrots)

Slices of poussin filled with chicken and herb mousseline

Smoked turkey, Pacific prawns, spring onion and chicory salad served with a spicy chilli sauce

Roast English turkey served with cranberry sauce

Smoked French turkey

Oriental duck salad (strips of duck with bean-shoots, mange-tout, sweet and sour sauce, red and green peppers — minimum 4 covers)

SANDWICHES

Wide selection served in granary or wholemeal bread

SCANDINAVIAN OPEN SANDWICHES

With an extensive range of delicious toppings

SPECIALITY OF THE HOUSE

Whole brie baked in pastry (ideal for large parties)

BARBEQUES

Greek barbeques with appropriate accompaniments (includes lamb and pork kebabs)

Home-made beefburgers with all the trimmings

Home-made country sausages

Mixed grills (includes steak, lamb and pork chops)

South Pacific theme barbeques

Spare-ribs in barbeque sauce

Tandoori chicken

SALADS

Basil, tomato and cucumber

Beetroot and apple in sour cream

Beetroot, celery and walnut

Broccoli, avocado and red pepper

Celeriac and radish

Chicory, orange and watercress

Coleslaw

Courgette, green bean, tomato and crispy bacon

Courgette and tomato

Cucumber in sour cream

Endive and quails eggs with Roquefort dressing

French green bean, broad bean, cauliflower and almond

German potato salad

Greek salad with feta cheese

Melon, cucumber and tomato

Mixed green (includes chicory, iceberg lettuce, endive and radicchio when available)

Mixed green with avocado

Mushroom à la grecque

New potatoes in whole grain mustard sauce

5

AFTER 4 YEARS OF HERBERT HOOVER, YOU'D REJECT REALITY TOO.

ABSTRACT PAINTING AND SCULPTURE IN AMERICA 1927-1944 APRIL 15-JUNE 3

The Minneapolis Institute of Arts

Organized by the Museum of Art, Carnegie Institute, Pittsburgh, PA. Made possible by the Hillman Foundation, Inc. and the National Endowment for the Arts. Local support provided by Dayton's.

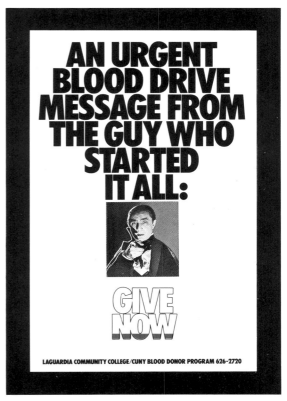

AN URGENT BLOOD DRIVE MESSAGE FROM THE GUY WHO STARTED IT ALL:

GIVE NOW

LAGUARDIA COMMUNITY COLLEGE/CUNY BLOOD DONOR PROGRAM 626-2720

■ **Left** The message conveyed here is precise and to the point and the no-frills typeface reflects this boldness. it still retains an appropriate, modern appearance, which is helped somewhat by the lighter subheading below. There is a harmony between image and illustration.

■ **Above** When the message you wish to convey is forceful, select a typeface that reflects this. The outline lettering below is, in fact, the same typeface and makes a clever visual pun out of this serious subject.

D eciding on the right color

This design expresses the meaning of the word with a delightful gradation of warm to cool colors. Using a pastel shade can soften and blend the image projected.

Each project you undertake will probably involve the use of color. You may find that you are able to produce the work in full color, or economics may dictate that it must be restricted to fewer colors or even various tones of one color. Remember, for each color you introduce a separate print-run is necessary, since, when the four-color print process is used, each color must always be printed individually.

Consider the color you choose very carefully — it will possibly be a major influence on the way you communicate your idea — and bear in mind that not every color will be appropriate for a particular design or product. For example, you will find that cool, light colors, such as blue and green, are often used to promote bathroom toiletries. The warmer ocher colors can project a summery image on the one hand or a leathery, classical feel on the other. Advertisements and packaging for perfumes often use a combination of these middle tones accompanied by gold and black, which give the feel of valuable metals and polished ebony by using the colors to represent natural materials. It would, however, be a misuse of color to suggest the use of pink in the sale and promotion of, say, machine tools.

In recent years it has become possible to use and mix bright, natural colors together. You often see a bright blue, yellow, and red all in the same piece of design, and this has been highly influenced by modern shop and living environments. I would normally associate bright colors with modern living styles and modern trends in mass communication, whereas darker colors, like the dark greens, burgundies, and French navy, are useful if you are depicting sophistication and quality. If, for example, you have a product that needs promoting by means of a company image first and foremost,

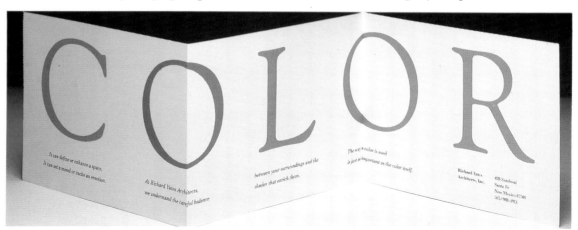

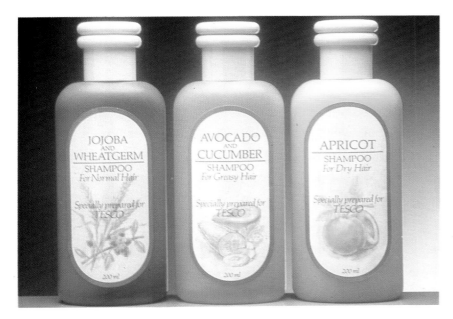

Left Packaging uses color to give an appropriate product image. The examples of shampoos shown here reflect their natural ingredients with a subtle tint of color. The illustrations are coordinated to help the overall effect.

and people associate the company with quality and reliability rather than with transitory high fashion, the application of these darker colors could be a possible design option. On the other hand, if you are promoting lively, active products or organizations, you may need to strike a balance between dark sophistication and bright, lively modernism.

At this stage, you will find it beneficial to make some observations from magazines, billboards, shopfronts and signs, packaging, and even TV commercials. Decide what image was intended and assess its suitability, and then build up a picture of what products seem consistent with certain colors. Look at design work from the past to see which colors can be used today to evoke the feeling of those periods.

The examples on these pages should be a starting point for further investigation. Finally, always experiment with different colors, assessing and modifying the image you wish to project.

Right This masculine-looking packaging is deliberately contrived to put over a marketable image to a well-chosen audience.

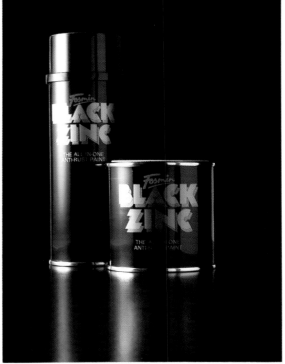

continued overleaf

Right The black background with the colorful illustrative lettering in the form of bodies dancing evokes a theatrical, vibrant appearance. The green acts as a complementary color, and gives a feeling of footlights.

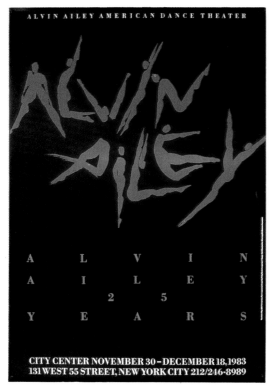

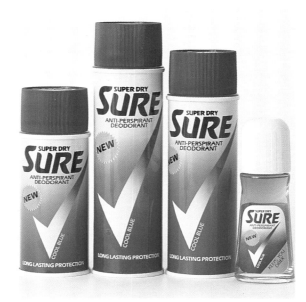

Above The color used here blatantly expresses the purpose of the product. One could not imagine a more suitable choice.

Below The packaging in this picture has been designed and coordinated to project an image of quality and sophistication, yet it still retains a modern, accessible appearance. The green is just lively enough to disassociate itself from a dour establishment image.

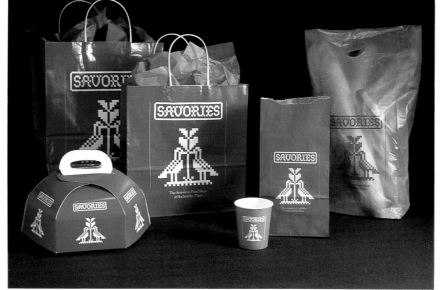

Tough messages can be softened by the careful choice of friendly color. This health care pack is made inviting, and one feels the creators must be caring and considerate.

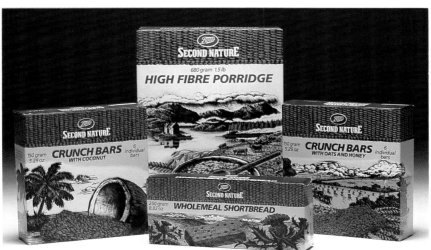

Natural food products require packaging that reflects their ingredients. This range of products plays on the traditional woven-basket effect that has a warmth and stability with which we can all identify and that are reflected in the illustrations. The color on the lid is echoed in the product name.

Creating a mood with color

Colors also offer the opportunity to project a mood or feeling. This can be as simple as choosing colors that evoke the seasons, but colors can also convey, by mental association, the feelings of freshness and harmony as well as of coolness and discord. Artists such as Picasso experimented extensively with the use of color, and you will probably be aware of his most obvious mood paintings, which are those produced during his Blue Period. All artists at some stage convey mood through color, and your task as a designer is to exploit, where required, the power of colors dynamically to create mood, either by themselves or in conjunction with images. Sometimes, for financial reasons or through choice, tones of gray can be exploited effectively, mainly to give the impression of weight and mystery. Add red to this, and you produce a dramatic result that has both tension and suspense.

Advertising makes full use of the subliminal nature of the effects of color. You will often see comparisons between, for example, a healthy, sun-tanned body and an anemic-looking figure. The rich color of the tan instantly evokes a mood of well-being, which associates itself with the product being promoted. The color of foods will be carefully used to generate an impulsive desire for that product.

Another important factor is the desire for romance, and you can consciously imply this in your design work by the use of soft, delicate, pastel shades of color, like those used in Impressionist paintings. Modern technology, on the other hand, in its desire to create a mood of professionalism, uses color, often in a minimal, unadulterated fashion, to convey a clean, sharp, and purposeful mood.

Obviously, the amount of color you use will be determined by many factors. The balance between all the elements of your design must also be determined, and your attention should at all times be directed toward the choice of shape, typeface, proportion, color or tone, and finally image and mood. Remember, all these factors are interrelated and, if considered conscientiously, will help your design to be successful.

■ Looking at this very subjective design you can safely assume that the personality behind it is lively and vibrant. Consider for a moment how you would describe a colleague simply with color.

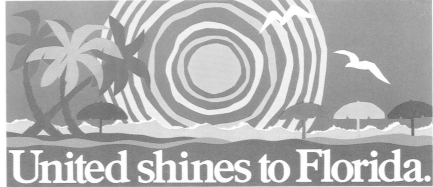

Left The designer has created an impression of night-life and excitement. He clearly intends you to see this as a center of fun and entertainment.

Left Colors can be used to give different qualities to the subject matter. It has been used to suggest a mood of menace and aggression.

Above These brilliant colors evoke a feeling of pleasure and leisure. The combination of colors is well chosen to dazzle and stimulate the senses.

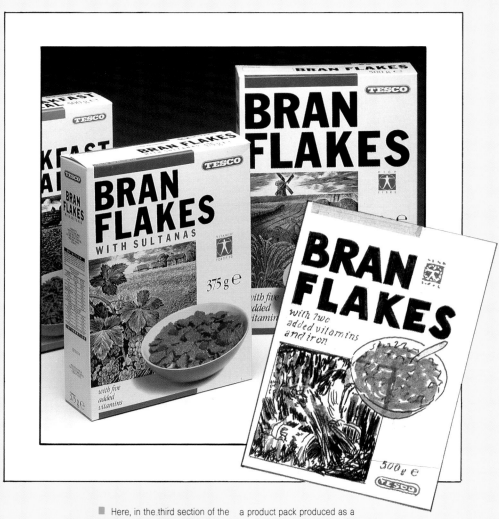

Here, in the third section of the book, you will encounter the full design process. The example here shows a mock-up design for a product pack produced as a hand-rendered visual alongside an example of the finished, printed pack.

THE DESIGN PROCESS

The first section of this book dealt with the concept of space and how elements can be arranged within the space to give effective, dynamic results. The second section observed, through a process of study, existing designs and how effectively the visual elements can be portrayed in a relevant way to their intended audience. You discovered the use of different typefaces, the various areas of design, the application of colors, the use of illustrations and photographs, and finally the way an image should be projected.

Now you are going to explore ways of evolving original and appropriate designs without the support of existing examples. You will be asked to collate the information you have gathered to implement an original idea, from the first briefing stages of the project, through the concept development, to the application of your ideas in layout and rendered forms.

To achieve this you must establish at an early stage the particulars of the project, whether it is for a client or for your own benefit. Assuming you are designing this on behalf of another person, you will need to identify that person's thoughts and ideas about the design requirements. They will have, through their involvement, inside information which will be invaluable to you in the creation of the most effective and appropriate solutions to their design problems.

Bear in mind that whenever you are faced with the complications and complexities of a design brief it is your task to find, eliminate, and resolve the problems raised in the most direct, dynamic, and simple way.

GOING THROUGH THE STAGES OF DESIGN
The first and most obvious stage is establishing the design brief. The next will be to understand the requirements posed by the brief. Research the market and media or the conditions and restrictions that may affect your piece of design. Ascertain the elements to be displayed within the design and its size and proportions. Now you can begin to use your creative senses to formulate the beginnings of a design and shape.

Draw up a shape in miniature, as thumbnail sketches. Position the elements within the design area. Introduce various typefaces. Bring in the use of color. Position any shape or design element that is to be included. You should begin to see the basis, in sketch form, of an emerging design. You will then need to extract a number of arrangements or ideas that can be worked on to evolve a more viable concept. Remember, your client or even yourself will need choices. It is possible to decide on the most effective, interesting, or practical design only if there is a choice. Finally, you will need to produce good, well-presented visual ideas to convince your client of the validity of your approach to solving his problems.

D esigning stationery

CHECKLIST

- Assess the projected image and its function.
- Decide on the method and color to project the image.
- Produce a choice of designs.
- Produce some final roughs on your chosen paper.

Every organization, whether it is small or large, will need something on which to write its letters. The first consideration is to keep the size and shape of your letter paper to conventional proportions, which you should establish by consulting the printer you or your client intends to use. The size of other items of stationery — business cards and compliment slips, for example — can evolve out of the way your design is established.

Obviously, the first task is to determine the information that is to be presented on the stationery. Next, investigate the qualities, styles, and colors of paper available to you. These are numerous and extensive and will affect the visual decisions you are to make.

Other considerations influencing the design are some of the technical processes and options that may help you express your image or concept. For example, printers can emboss shapes or letter forms out of the paper by a process known as thermography. You could even die-stamp images cut out of paper. More commonly, however, companies will be looking for a practical and economical approach. Remember, they are likely to use vast quantities of stationery, and unless they

Below Here you see the logo with the company name arranged in the style chosen for the final presentation. This combines good balance with a sympathetic size of typeface, while the logo unites the company name with the company image.

are totally dependent on the image it conveys, they will more often than not opt for the least expensive but most effective presentation.

This brings me to color. Again, try to limit the number of colors used in the production of your stationery. Balance the color of the paper with the colors you intend to print. Sometimes the use of full color is unavoidable, but establish this first before creating an exhaustive range of designs.

■ **Below and right** There are many ways in which the type and image may be used. Here are a few of the possible options, showing the text and logo in varying positions. Each of these ideas creates its own sense of space and image.

NEW QUEBEC QUISINE

NEW
QUEBEC
QUISINE
LIMITED

N E W
QUEBEC
QUISINE

N E W
QUEBEC
QUISINE

NEW
QUEBEC
QUISINE

continued overleaf

Letterheads

CHECKLIST

- Establish the position of any image or logo.
- Choose the papers for the design; take advice on suitable weight.
- Make sure that your design is compatible with standard available envelopes.
- Draw up a number of typefaces.
- Divide the information into visual priorities.
- Establish the proportions of your letter forms.

A letterhead is so called because the design will occupy the head of the sheet of paper, allowing the rest of the sheet to contain a letter or message. Occasionally the foot of the letterhead will contain a printed element, such as the information required by company law, or even more design elements. Establish what is needed at the briefing stage.

Mass-produced stock envelope sizes are available, normally made up in your chosen paper. Make sure that your design fits comfortably into an available envelope size. You will need to fold your letterheads, so make sure that your design works when the paper is both flat and folded, and that an address can be typed to align itself with the aperture in window envelopes.

You are now ready to start your design. Establish the position of any company image or logo. Select some appropriate typefaces. Think about the paper and colors you wish to use. Divide the information

into visual priorities, establishing the proportions of your letter forms. The position and size, along with the way you present this information, will be crucial to the effect you wish to convey. Produce a selection of compositional arrangements and colors as the basis for your final choice.

Finally, it is not uncommon for the envelope also to carry your design, but keep this to one color, since there are technical restrictions on printing made-up envelopes.

■ The design for the letterhead shown here is the one selected by the client.

NEW
QUEBEC

QUISINE

NEW QUEBEC QUISINE LIMITED
13 NEW QUEBEC STREET · LONDON · W1H 7DD · TELEPHONE 01-723 0128/3184

■ **Above and right** These designs show some of the alternative ways in which the logo, company name, address and company information may be positioned. Please note that letterheads may be required legally to display certain registration details; you should always check these before proceeding with your design.

D esigning a business card

Normally business cards follow the style, color, and image established earlier in the creation of the letterheads. Naturally, the information contained on the business card will be decided by the client, but the size and shape of most business cards conform to restrictions such as pocket or wallet sizes, and they are normally required to be about the size of the standard credit card, so that they are not destroyed because they are inconvenient to carry around or keep.

You will have to make provision for including the name and position of the executive for whom the card is intended. Always make sure that the executive's name is clear and separated from the main company design. Normally the position held by the executive would appear less prominently beneath his or her name.

Remember also that the card will not be printed on the same stock as the letterheads but on a heavier paper, and you should seek advice on an appropriate weight of card. Although there are many conventional approaches to business card design, you should attempt original and dynamic ideas to make your design stand out from the rest.

■ By varying the size and position of the logo and company name in the design space you can create a range of emphases. Change the area of the design space by using the card in a landscape or portrait format. The examples here show a few alternatives together with, **above right**, the finished printed piece.

Designing a compliment slip

CHECKLIST

- Decide on the shape and size of the compliment slip.
- Consider a number of alternative shapes.
- Suggest both conventional and original shapes.
- Try the design using different proportions.
- Keep the typefaces and paper consistent with the letterheads.
- Establish the additional space required by the client.
- Relate your design to its function.
- Produce a number of original alternatives.

By now you have established a formula and design for the stationery. The biggest decision you now have to make is the shape and size you intend the compliment slips to be. Although there are many unusual and interesting shapes that you could use, for practical reasons most companies these days prefer their compliment slips to be accommodated in standard size envelopes, and the slips will tend to be cut to a third of the letterhead size, in horizontal format.

I do not think that this should restrict your creative suggestions, and some original alternatives should be offered. Again, the image presented would be established at an earlier stage in the letterhead designs, but you should also determine the message that is to be shown as well as how much space is required for additional written information.

Remember, compliment slips may be attached as supplementary support to the main material being dispatched, and you should investigate what this material is likely to be so that you relate your design to its function. Finally, the paper the slip is printed on should be coordinated with that used for the letterheads.

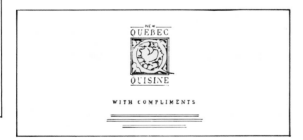

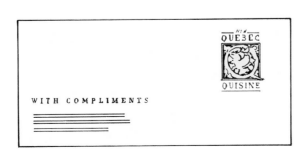

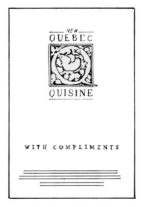

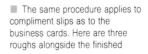

■ The same procedure applies to compliment slips as to the business cards. Here are three roughs alongside the finished piece, **above right**, which conforms to the design of the business card and gives balance and uniformity.

D esigning an advertisement for print

CHECKLIST

- Define the design elements.
- Define the size and shape of the advertisement.
- Mark this out a number of times.
- Produce a number of alternative layouts.
- Vary the style of type.
- Balance the elements.
- For smaller advertisements experiment with borders.
- Vary the tonal effects.

Advertising can be an expensive and risky form of communication, because in a very short period of time and using a limited amount of space you have to convey and communicate a positive message. Advertising is sold according to size, the number of colors in which it is printed, and the size of the readership. For example, an advertisement in a large national magazine is extremely expensive, whereas advertisements in a regional publication, whose readership will be limited, are less expensive. The copy and heading are often the most important factors in the preparation of advertisements. Nevertheless, the designer has a crucial role in presenting, in a space that will be pre-determined by cost, the elements that are to be used in the advertisement.

The essence of good advertising design is clear and uncluttered presentation. The use of well-considered typefaces is most important, and if photographs and illustrations are to be included, these should be relevant, clear, and in harmony with the subject or product being advertised. A note of caution: always be aware that your design may have to appear in several different publications, where it will occupy a variety of shapes and sizes, so make sure that it is flexible and that the elements can be adapted for different sizes.

Finally, if you design small advertisements that are placed close to reading matter, you may be wise to incorporate into your design some device, such as a border, to separate your valuable space from the text surrounding it. Most advertisements will appear in black and white, which gives the designer an opportunity to experiment in tone.

■ The decision on the size for your design will be determined by the space your client intends to buy in a publication. Bear in mind that, as long as the space remains in the same proportion, the actual design area can be landscape or portrait. The decision you have to make is which will be more suitable for the elements of your design.

Your client may decide on booking many different sizes of advertisement. In this case, it is important that the ingredients used in the design retain a visual coordination whatever size they may appear. The variations in advertisement sizes are known as "adapts" and the examples shown here demonstrate the design applied to different formats.

We're happy to admit that this beautiful brush is a long way behind the times.

There's absolutely nothing new in the way it's made, slowly and carefully by hand.

And the components we use, frankly, have been known to the world for centuries.

Nothing in existence, natural or manufactured, performs like the tail hair of the Kolinsky Sable when it is skilfully fashioned into an artists' brush.

So naturally we use the real thing, finest Kolinsky Sable.

Likewise, no machine can grade and form these delicate hairs anything like as accurately as a skilled eye and hand.

The result is one of the finest brushes money can buy, a brush with the natural spring and resilience to point-up to perfection and retain its original shape. Its unique texture also permits the maximum amount of liquid colour to be carried, and allows a controlled, free flow onto the painting surface.

Of course, they are rather expensive and, due to the scarceness of suitable Kolinsky Sable, the larger sizes are not always available.

There are some alternatives to Kolinsky Sable which sell at a fraction of the price and which perform quite nicely for many applications. Indeed, here at Rowney, we make a whole range of brushes for all levels of ability.

But, for watercolour in particular, and for fine oil work, once you've experienced the beautiful touch of Rowney Kolinsky Sables, you'll never want to be without them.

OUR REPUTATION IS IN YOUR HANDS.

Rowney
FINEST KOLINSKY SABLE

THE EXQUISITE DIANA KOLINSKY SERIES IS AVAILABLE FROM SIZE 000 TO SIZE 14. ALSO IN KOLINSKY SABLE. WITH SHORT HANDLES.

FINE POINT, DESIGNERS AND RETOUCHING SERIES; AND, WITH LONG HANDLES, ROUNDS, RIGGERS AND FLATS.

Daler-Rowney Limited, Fine Art and Graphics Materials
Made in England. From all good art shops.

Designing a newsletter

CHECKLIST

- Consider the design brief and intended readership.
- Establish the financial restrictions on shape, size, and number of colors.
- Design a masthead.
- Treat this as a separate design project.
- Consider the shape and size of your design area.
- Consider the layout of the pages.
- Draw your design grid.
- Apply your copy to the design grid.
- Establish the amount of copy on each page.
- Introduce the other elements to your grid.
- Consider the use of color in your design.
- Draw up the inside pages.
- Prepare full-size visual presentations of the front and back pages along with a typical inside layout.

Large or even medium-sized companies often publish a newsletter through which they communicate with their staff and sometimes their clients. The newsletter provides a platform from which the company can convey to a large audience the social and business activities and developments taking place within the organization.

The size of the newsletter will depend on financial constraints and the amount of information available, considerations that will also affect the frequency of publication.

Another factor that will affect your design decisions is the amount of color you are able to introduce into your work. Normally only one color would be available for the main content of the newsletter, although a second color may be used in the main title of your front page, and you may also wish to use the second color to help emphasize other elements.

■ The examples shown here use three alternative double-page grid layouts. As most of the information to be included in the newsletter will be text, this will be the first design element to consider when you plan the layout.

A Three column grid

B Four column grid

C Five column grid

First, you will need to design a masthead — the heading or main title that will become the established style for all issues of this publication. This can be designed separately from the main work, for your client will probably wish to see various alternatives.

Next you should consider the shape and size of your design area. Since this piece of work will have a limited circulation, it may be an opportunity to introduce some original shapes or sizes to your design. A word of warning, though: make sure to consult with the printer to establish the practicalities of printing and trimming the final piece.

LAYING OUT YOUR NEWSLETTER

Your first task is to determine the copy and visual elements that are to be included. The copy should be typed so that you can establish easily the number of words and so that the typesetters can work comfortably from the text. The simplest way for you to work out how large your typeface should

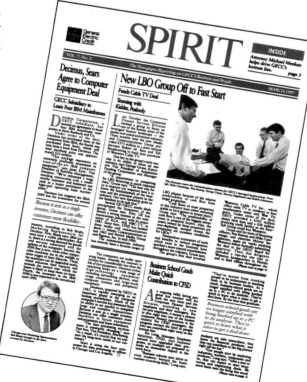

■ In the design shown on this page it is obvious how the visual emphasis changes when different grid layouts are used. These layouts will also help to position the main title (or masthead) of your newsletter.

Left The final, printed version uses a formal 4-column grid layout, but notice how the formality is broken with the free shapes created by cut-out photographs. The blue is used to take the eye from the importance of the heading down through the written information.

continued overleaf

Decimus Corporation, a GECC subsidiary, has entered an agreement to lease four IBM mainframe computers to Sears Roebuck and Co.

Under terms of the deal,

Nothing is more valuable to GE Credit's future and nothing creates more opportunities for people than the excitement of helping to expand our businesses — creating new growth initiatives that can

GECC President Gary Wendt gave President's Performance Awards to general managers of four GECC businesses at the

Corporate lawyers. They're never in the spotlight, so they don't get much recognition. But people who work with them every day will tell you that the bottom line wouldn't be the same without them.

■ **Above** Pictures can be produced as half-tones or blue can be added in equal amounts of tone to create duotone effects. Tints of blue can also be placed behind text or pictures to create a light background shape for your images.

■ On this page we have isolated some of the changes in type that have been used to break up, emphasize and add visual interest to the masses of body copy included in the newsletter. Note that the typeface used for the body text in the main newsletter is all serif; however, in the special feature section, it has been

changed to a sans serif face to give this section an identity of its own. You will also note that the boldness of some of the subheadings and the indented drop capitals used to lead each column of text are softened and give an illustrative quality by the use of the blue.

Agree to Computer Equipment Deal

Business School Grads Make Quick Contribution to CFSD

GECC HE★DLINERS

Growth Initiatives

There are a lot of deals that just don't fit the standard mold. Deals

Because it acts as a single investor, Decimus can offer

be is to find some existing examples and use these as the basis for calculating how many words will fit on a page. Type and depth scales are available to help you calculate accurately the weight, style, and size of type.

You will need to establish a design grid for your text and design elements, and you should decide on this first and draw it up before introducing any other design elements.

The next stage is to design your front page. Bring together your masthead design, your grid and the design elements — photographs, illustrations, and graphic devices — and produce a number of alternative layouts for your front page, gradually introducing the use of color.

Remember, if you are restricted to the use of one color, make sure it is dark enough for your text to be legible.

The inside pages will naturally be formulated around the grid design established on the front page. When you present your concepts to your client you should show how the inside pages work, since these will become the typical format for future issues. The design procedure will revolve around the application of body text, but try to introduce interesting graphic devices and innovations to prevent these pages from becoming staid and insignificant.

Finally, you should always bear in mind that the front and back pages will set the tone of your piece of design. Make sure that the characteristics of the readership are taken into account at every stage of the design.

In these layouts you can see the degree of presentation you need to achieve in the preparation of your designs before arriving at the final ideas, **right**, which will represent the finished printed piece.

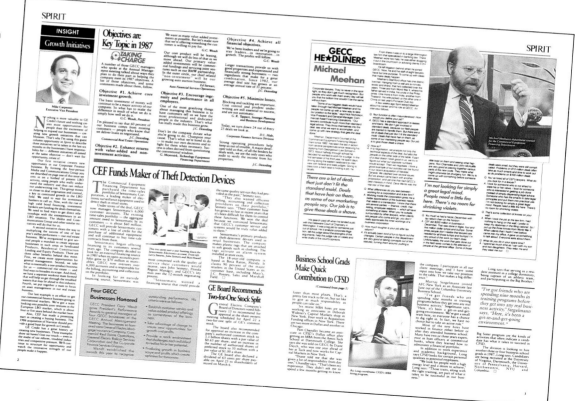

Designing an insert for direct mail advertising

Designing an advertisement for direct mail advertising offers an immense amount of visual freedom, although there will be some constraints. The client uses inserts for many reasons, for they present a format within which can be shown in short and sharp detail the product or service and at the same time offer the customer a convenient means of reply, which is usually incorporated into the design in the form of a pre-paid response card. Normally, the content of the insert is determined in advance, and this may affect the presentation and importance of the visual elements. However, the excitement of this kind of work lies in the construction of the insert and the freedom it gives to explore dynamic visual images through color, illustration, and photography.

The first stage in designing the insert is to divide up the information into areas of importance. Naturally, the portion of the insert that is seen first must have the greatest impact and entice the viewer to investigate further. When the message has been successfully conveyed, you must guide the viewer through the information and on to the direct response card, where he will either apply for the services or goods or commit himself to a purchase.

Take some time in experimenting with the size and shape of your insert, trying various folds giving you different shapes. You will need to bear in mind some technical considerations, and the first of these will be the dimensions of the pre-paid reply card. Investigate the permitted proportions with the postal authorities. You should also find out if there are restrictions governing the minimum weight of paper that can be sent through the post, even though your client will want to keep the insert as light as possible for financial reasons.

■ These examples show some of the possible ways of folding your insert to gain the best effect from paper or card of standard dimensions. This may be conditioned by the publication into which it is inserted.

■ 4 Page Portrait

■ 4 Page Landscape

■ 6 Page Accordion

■ 6 Page Portrait

■ It is important to use the front of your insert to gain maximum impact for your message. Here you can see various approaches to solving this problem. The final example conveys impact both from the heading and in showing the product effectively.

Finally, the client will probably wish to see various alternative approaches to the insert design, and this may be an opportunity to consider different visual approaches. Illustrations, for example, can offer another dimension to the presentation of reality, while carefully controlled photography can help to suggest a mood and atmosphere to the viewer. When you present your visuals, make sure that they convey as closely as possible a true representation of the finished work.

continued overleaf

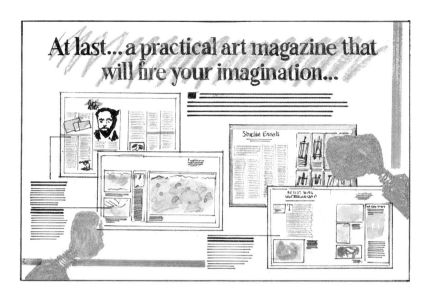

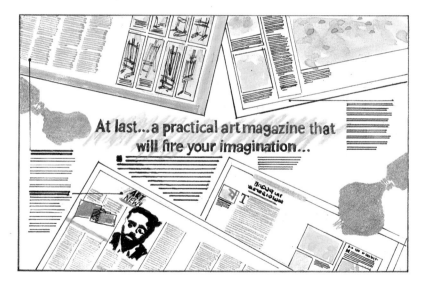

■ The function of the inside of this insert is to describe in more detail the product while guiding the reader to the subscription section where the intention is to sell the product. You can see that different layouts for this offer up alternative effects.

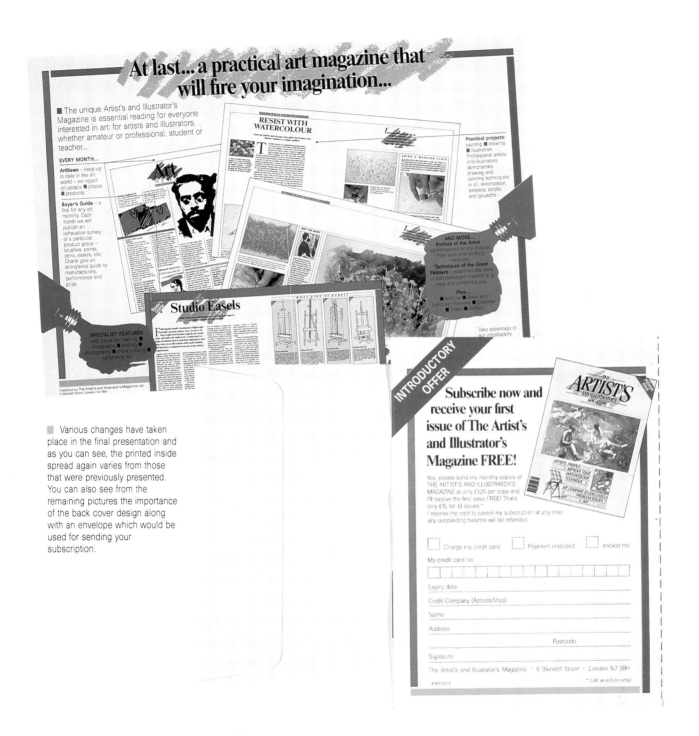

Various changes have taken place in the final presentation and as you can see, the printed inside spread again varies from those that were previously presented. You can also see from the remaining pictures the importance of the back cover design along with an envelope which would be used for sending your subscription.

D esigning a full-color brochure

CHECKLIST

- Consider the means of delivery of the brochure and its readership.
- Consider its size, shape, and proportions.
- Design some alternatives for the covers.
- Produce a number of grids for the design of the inside pages.
- Decide on the typeface.
- Produce a number of alternatives.
- Explore the visual effects of color.
- Combine these elements into a formal design.
- Present your cover designs together with a typical inside spread.

What is a brochure? It is, in effect, a booklet or pamphlet that describes a service or product and assists in its sale. In addition, it should convey the quality and character of the service or product described.

In preparing a brochure for your client you will need to identify the items or services that are offered and obtain a full description. Your first consideration should be how the brochure is delivered to the potential customer. If, for example, it is to be on display alongside competing products or services, it will need to be sufficiently different from those, but relevant to its subject, to attract attention. Your design may, therefore, be conditioned by existing designs. Alternatively, if your brochure is being sent direct to the potential customer, there will be far fewer physical restrictions, apart from the fact that it may need to fit into a standard envelope.

When you have established how the brochure will be presented, you can proceed with your design. The first step is to design the front and back covers. Look at the shape and experiment with the color and paper qualities. Produce a number of alternative concepts, ranging from simple sophistication to complex, informative designs. Decide which of these will be the basis for your design, for this will affect the entire visual content of your brochure.

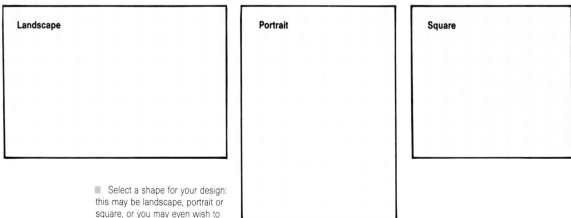

Landscape

Portrait

Square

■ Select a shape for your design: this may be landscape, portrait or square, or you may even wish to try a less conventional format.

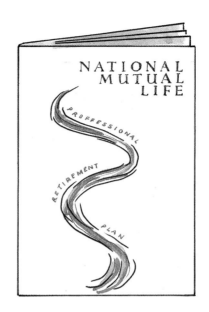

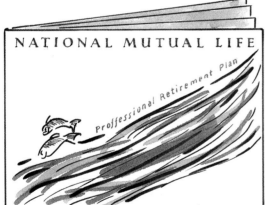

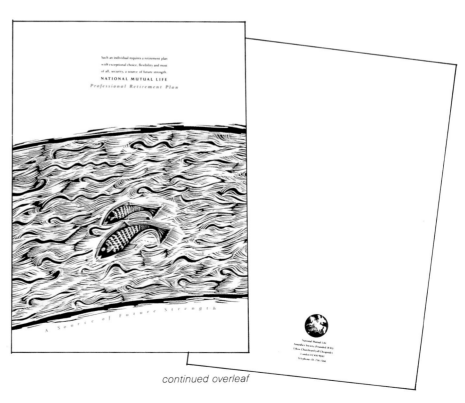

■ The inspiration for this front cover is derived from the text to be included in the brochure. The style for the idea should be expressed by using different design arrangements. The alternatives shown here in rough form give you some idea of the design route. **Right** The final design uses a woodcut illustration with the fish depicted in silver. The typography is kept very light and unobtrusive and the letter forms have been carefully spaced to emphasize this visual caution. The back cover has been used solely for the delicate company logo.

continued overleaf

LAYING OUT THE PAGES

When you have determined the style to be used for the cover, you will need to discover a formula for the design of the inside pages, which should complement the visual effects set up in the earlier stages. On the other hand, you will be influenced by the amount of text and visual information to be included. Again, you will need to decide on an effective arrangement for your type. Produce a number of grids and select one that gives you both sufficient space to fit the copy and enough scope to achieve the style and character of your design.

CHOOSING THE TYPEFACE AND COLOR

When all the spatial design decisions have been made, you will need to choose the typeface and color. Produce a number of alternatives for the headings and text to be used throughout the brochure before proceeding to your final designs. You should also prepare alternatives to show how you intend to use color. This should be considered very carefully at the rough layout stage, and you should experiment with the alternatives as thumbnail sketches before applying them to your final design.

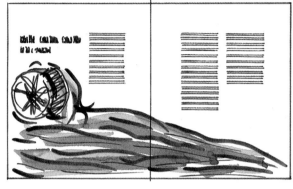

Continuing with the theme of the flowing river, the inside pages of the brochure carry illustrations using the same formula throughout. The text needs to be arranged to retain the light, open feel of the front cover. A number of grid arrangements have been indicated in these roughs.

■ The rough layouts for the pages shown here balance the illustrations and text by positioning a block of text on the left while allowing the illustrations to fall freely on the right.

continued overleaf

Lorem ipsum dolor sit ammet, tempor inncidunt ut labore et veni mole stiaeh consequat, vel euismod tempor incidunt ut enim ad nost rud exercitation ulla sum corper duis autem vel eum irure dol incidunt ut labore et atib saepe eveniet mut sper repudiand tenetu veniam, laboris nisi ut aliquip ex ea atib seape eveniet ut meer re lorem ipsum dom savlor si amet, incidunt ut labore et dolore magn.

■ Perpetua Roman, u/lc, justified, 10/18pt.

Lurida praeterea fiunt quaecumque tuentur arquati, quia luroris de corpore eorum semina multa fluunt simulacris. Fugitant uitantque tueri; sol etiam caecat, contra si tendere pergas propterea quia uis magnast ipsius, et alte aera per purum grauiter simulacra feruntur, et feriunt oculos turbantia composituras. Praeterea splendor quicumque est acer adurit saepe oculos, ideo quod semina possidet ignis multa,

■ Gill Sans Regular, u/lc, justified, 9/17pt.

Corpore eorum semina multa fluunt simulacris. Fugitant uitantque tueri; sol etiam caecat, contra si tendere pergas propterea quia uis magnast ipsius, et alte aera per purum grauiter simulacra feruntur, et feriunt oculos turbantia composituras. Praeterea splendor quicumque est acer adurit saepe oculos, ideo quod semina possidet ignis multa, dolorem oculis quae gignunt insinuando. Urida praeterea fiunt quaecumque tuentur arquati, quia luroris de corpore eorum semina multa fluunt simulacris. Spolendor quicumque est acer.

■ Century Medium, u/lc, justified, 8/14pt.

■ When a typeface to complement the brochure design was selected a number of possibilities seemed relevant. In the three ilustrated, **left**, you can see the various effects the change of typeface can make. Each is a traditional face, but used with differing line spacing and setting decisions. **Top left** is the chosen face for use in the brochure.

■ Another component of the design is the use of captions running around illustrations. An example of how this works is shown above.

■ The final visual materials will be produced using a woodcut style overlaid with washes of subtle colored inks. **Below** The example shown is a test piece for the final printed work. You would need to be quite clear about the visual presentation of your final illustrations so that you are able to locate and brief an illustrator who can work to the style you wish.

■ The final printed pages demonstrate the use of many subtle but effective ideas.
Top left You can see the use of blue as a solid background, enabling the type and some of the woodcut to be lifted out in white. In the other pages shown the main text is formally displayed, while some of the key information darts across the page following the illustrations and picked out in a color. The theme of the river is used faithfully to the end, where even the folios (or page numbers) are reversed out of small fish illustrations.

D esigning a poster

■ When you are designing a poster the first decision to make is the size and shape of the design area. This may be governed by the display site. For this example three shapes have been explored: two differently proportioned portrait shapes and one landscape.

At its best, poster design is the territory of the truly creative, and it has been used in the past as a public display of individual talent — I am sure you can recall some of the great exponents of the art. When you are designing in this graphic form, the poster's purpose and application should be your first considerations. The poster will normally be on display in a public area, and it will have to compete both with its surroundings and with other posters.

You should use this medium as a means of communicating your message directly to your audience, but before you begin your design you will have to take several factors into account. First, you must establish the actual information to be communicated. Next, decide on the size, propor-tion, and shape. Then you will need to know the possible sites and locations in which your poster will appear, since these may play a part in the decisions you make. Your client will be happy for you to employ your artistic talents, but at the same time he will expect his message to be conveyed by the simplest and most direct means. Remember, unlike a brochure or a newspaper ad, which is intended to be perused, your poster may be viewed for only a split second by a passing motorist.

The poster may well cover a large area, but you should follow your usual practice of making a series of initial thumbnail sketches before you produce a large, but manageable, scaled-down version of the final presentation.

²⁄₃ Portrait Portrait Landscape

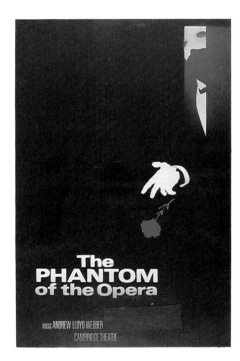

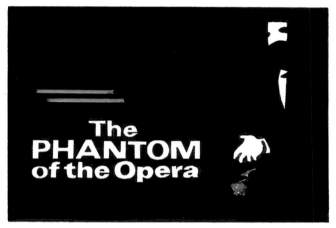

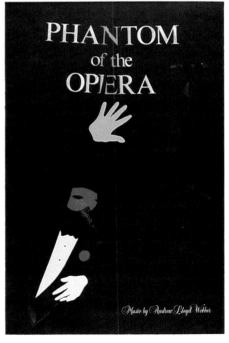

Your design will revolve around the proportions of the elements that are on display, and you should view these as negative forms, as described earlier. The essence of your design and the force of its message will be controlled by the calculated stress and tension that you achieve within the design area.

Typography will probably play a vital role in your design, and you should consider the shape, and style of the typeface, and the image it conveys, since the written word may be your first priority. If, however, the visual imagery is the element that is to attract attention, you must be sure that your audience can easily grasp some meaning or derive interest from what you portray.

■ The information to be included on this poster has been established. The three examples use alternative typeface styles and vary their position vis à vis the illustrative content. The design elements of the poster make full use of the visual imagery from the show itself.

continued overleaf

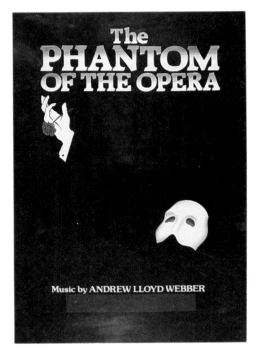

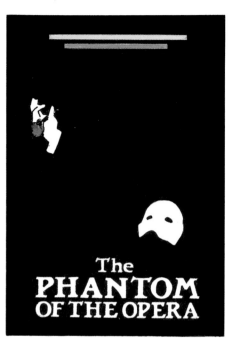

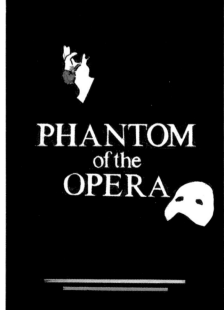

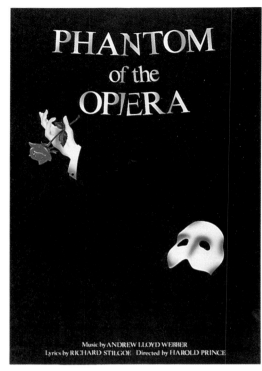

■ A selection of alternative designs allows you to begin to distinguish the various elements involved and degrees of effectiveness of each. You can see the style of typeface that projects the message in the most dynamic way.

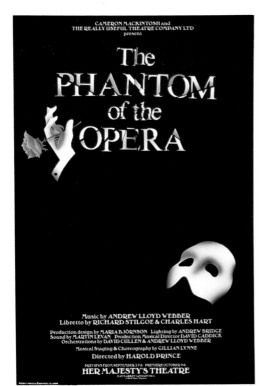

A distillation of the most effective elements from the previous designs comes together in the final presentation. Note the finished design has removed the hand and enlarged the mask. This final touch eliminates superfluous detail and emphasizes the most important images conveying an effective and dynamic poster.

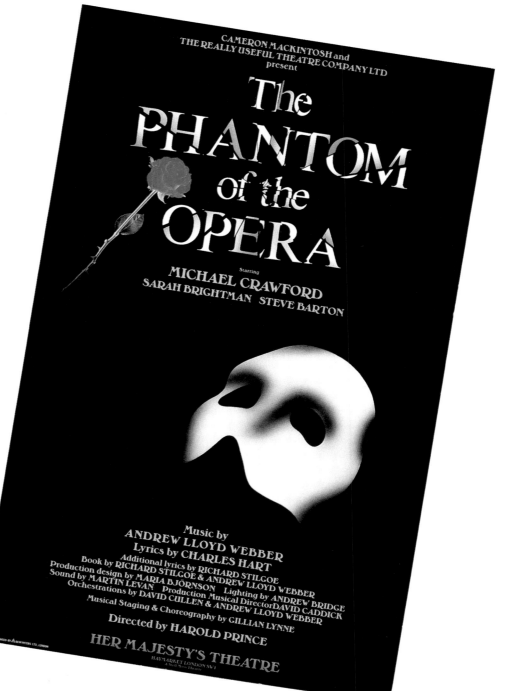

D esigning for packaging

CHECKLIST

- Establish the shape, size, and proportions of the product.

- Remember to consider label and product surface design if necessary.

- Research the market.

- Establish the price, quality, and image of the product.

- Consider the possible packaging shapes.

- Consider the shelf space available.

- Produce some mock-ups of your package shapes.

- Consider the technical and constructional factors.

- Explore some existing examples.

- Produce a flat-plan of your container construction.

This is an area of design that will give you an opportunity to explore the possibilities of using two-dimensional surface design to produce a three-dimensional display. The first part of your brief will be to establish the shape, size, and proportions of the product you are going to package. You may be able to influence the client's intentions in this area, although this is likely to be a very rare luxury, since the product is normally already designed. If the product to be packaged is in a bottle or container, you may also be instrumental in influencing the surface and label designs that will be applied. For this project, however, you should

assume that you are going to package the product, and I shall concentrate on the problems this involves.

First, you will need to investigate and research the market for your product. Look for its competitors and assess the position of your product in the market. Establish its price, quality, and image within that market; for if the product costs twice as much as its competitors, its quality, in terms of value and image, must be perceived to be twice as good.

When this research is complete, you will need to consider the shapes that can be created to contain

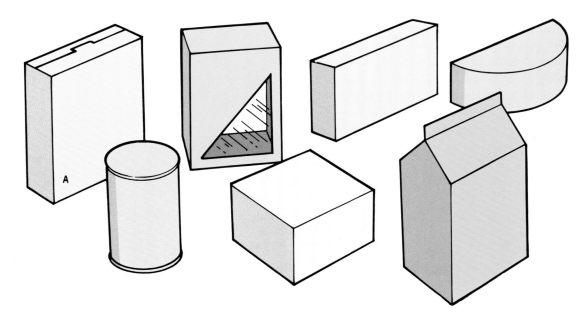

■ As you can see from these examples, there are numerous shapes, sizes and constructions that can be used effectively to package almost anything you wish to name.

It is important, when a decision on pack shape is made, that you understand the design area and its basic structure before undertaking the surface graphics. The illustration here describes, as a flat plan, construction **A** on page 134. From this you can see both the make up for the pack and the areas that require a design. Any pack you choose as your product container will require a three dimensional mock-up.

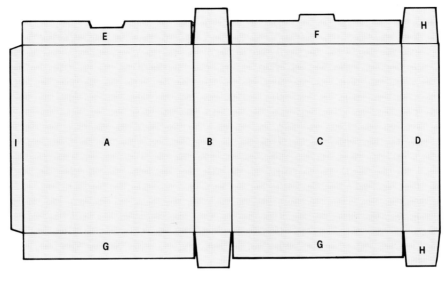

A Front
B Side
C Back
D Side
E Front flap
F Tuck flap for front flap
G Base flaps
H Side flaps
I Glue seam

CHECKLIST

- Make a number of sample packs in a variety of materials.
- Produce a number of surface layouts.
- Divide up the information.
- Consider the visual effect of multiple display.
- Choose a range of typefaces.
- Evaluate the style and image they convey.
- Introduce color to your layouts.
- Consider the color associations of your product.
- Research the colors used by competitors.
- Reverse the elements out of darker colors if you wish.
- Apply your ideas to full-size mock-ups.
- Re-assess your design ideas.
- Extract the best visual ingredients.
- Use these to produce more designs.
- Produce a final pack or packs rendering the designs to all surfaces.

the product. Beware, however: most stores and supermarkets have very limited shelf space and will be looking for the most economic proportions in packaging to display on their shelves.

DRAWING THE SHAPE

Produce a number of shapes that are ideally suited to your product, trying to be as inventive and original as possible. Produce a number of full-size constructions out of plain card or board to assess the visual effect these create. When you are happy with a particular shape or design, you will need to consider the technical, constructional factors, and these may force you to reconsider your choice of shape. However, before reaching a decision, you should dismantle a number of available examples to see if there are any constructional devices that you can put to work for your own design.

CONSTRUCTING YOUR PACKAGING

When you have finalized the container for your product and investigated the viability of its manufacture, you should draw up a flat, accurate plan of its construction. This can be traced onto various surfaces to make up sample packs in a variety of materials.

THE LAYOUT OF YOUR PACK

Establish the visual ingredients that have to be incorporated into the design of the surface of your pack. Remember, the advantage of a three-dimensional surface is that you do not have to cram all the information onto one surface. It is better to use two opposite facing sides to display the most important messages, leaving the remaining surfaces for technical and legal information. On the other hand, you may be lucky and have to display

■ The emphasis in describing this product range is the link between acceptable branding style described by choice of type and the various options in positioning the visual content.

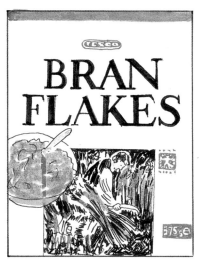

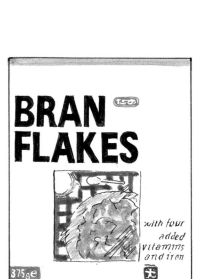

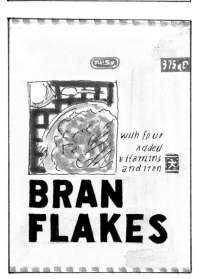

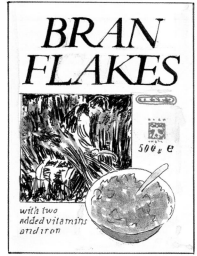

■ Here you can see some of the visual options produced using various typefaces and alternating the position and size of the visual matter.

only minimal information, which will allow you to use all the surfaces for your design. When laying out the information, try to play each surface of the pack against another, which will give interesting visual variety when the packs are displayed in formation. Finally, experiment with the proportions of the visual elements, to decide on the best design arrangement.

CHOOSING A TYPEFACE

The next consideration will be to make the right choice of typeface. By this stage you will have a good idea of the proportions the visual elements occupy, so the decisions you are now faced with are those concerning style, weight, and product image. The choices of typeface can be accurately assessed only by producing a number of examples of the main heading to evaluate the styles and images they convey.

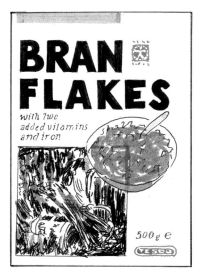

COLOR

Having established the layout and type possibilities, you can now consider the colors you wish to introduce and experiment with. As we have already seen, the mood or qualities implied by the product will influence your choice of color. For example, a domestic product may demand packaging that is in a color or color range that projects an image in the customer's mind of its function and effect. Beware of using unsuitable colors, and always consider the nature of the product and its eventual use. Clearly there are some established, safe, visual formulas, and you should look at the competition and benefit from their experience.

Make full use of the reversing-out technique when applying a dark color to your design area.

WORKING IN THREE DIMENSIONS

Having made a variety of design decisions, you should now see how they work full size and applied to the surfaces of a number of three-dimensional mock-ups. At this stage, to make the necessary visual comparisons, you will need to produce only two surfaces for each of your design alternatives.

■ As the concepts evolve, more detailed versions of these packaging ideas need to be realised. These visuals show, with color and precision, the final effect of one face of the printed package.

continued overleaf

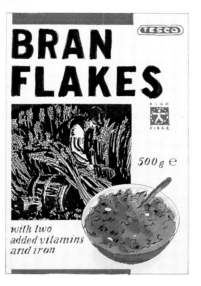

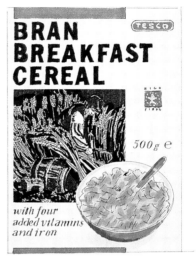

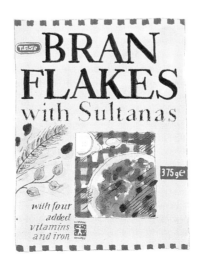

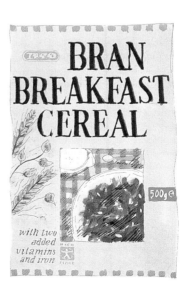

■ The next task is to test the designs in a three dimensional format. Each of the concepts will be made up into packs constructed to actual size, allowing decisions to be made on how the edges, top and bottom, can be used to enhance the overall effect. The examples illustrated here show the level of visual rendering this form of presentation should demand.

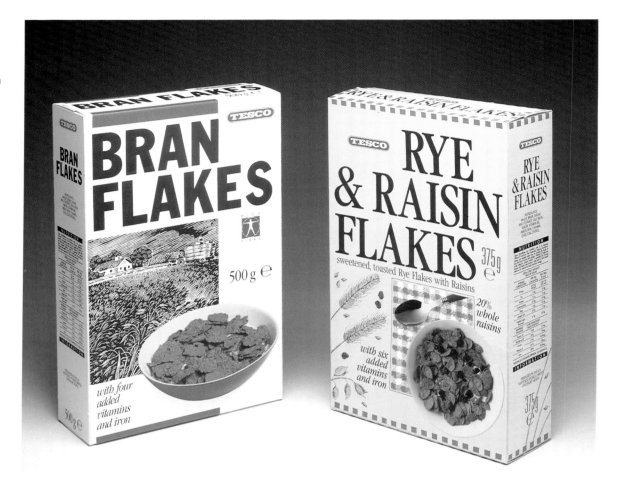

BALANCING TYPE, LAYOUT, AND COLOR

The result of transforming your two-dimensional design ideas into three dimensions may well leave you with different ideas about the validity of your design approach. However, the examples you have made up can be used as the basis for further development, and you should extract those factors that present the most relevant ingredients to help you reach a final design solution.

Nevertheless, this will be an opportunity to explore the most visually pleasing and effective conclusions by manipulating the typefaces, layouts, and colors extracted from the best of the short-listed design alternatives.

Finally, you need to produce a presentation of your proposed solutions. These should be carried out covering all the design surfaces with a highly finished rendering of your chosen design.

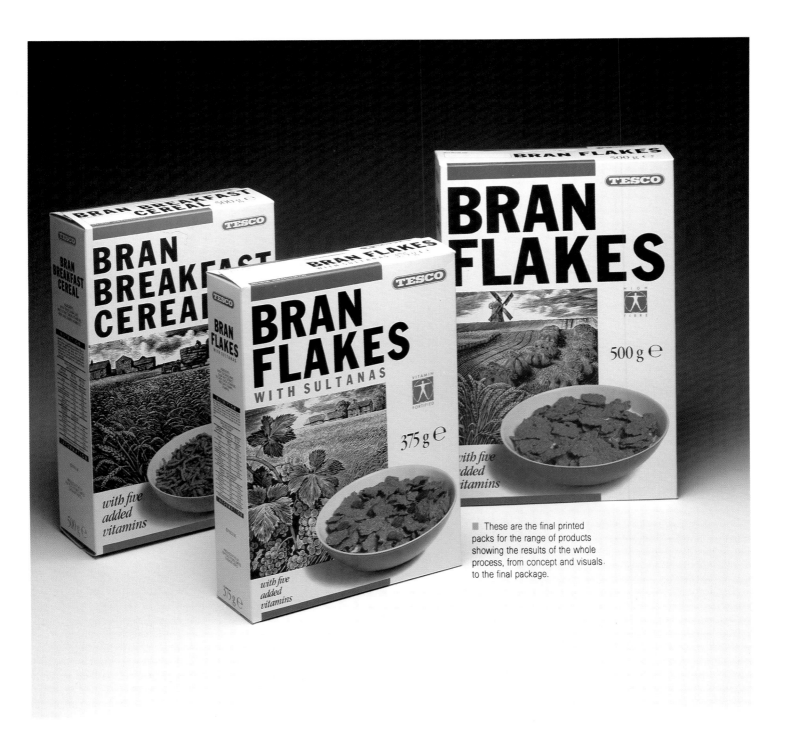

■ These are the final printed packs for the range of products showing the results of the whole process, from concept and visuals to the final package.

L inking the designs to other promotional material

In these pages I have viewed design as it is applied to individual promotional or display items, although you will often find that once your client has developed an appreciation of your graphic work he will be encouraged to use your services for other design projects. To be ahead of this eventuality, always consider the designs you are producing for your client as part of an overall process of co-ordinating and developing an image for all the graphic material he requires. By doing this, you not only will give priority to his business but will always be one step ahead as the company evolves. On the other hand, the design brief may be to co-ordinate the visual presentation of many items from the start. Whatever situation you find, there are some elementary factors to consider.

First, the style of typeface needs to be sufficiently distinctive to create a family image throughout the entire range of material. The layout and the feeling of space created in this process should be echoed on all items. The other elements — illustrations, photographs, or graphic devices, for example — are not quite so important. The color you choose will, however, be absolutely critical. By carefully using the color in the same proportions, consistently throughout your designs, you will be well on the way to finding effective design solutions.

■ You can see how some companies exploit the full impact of their company image by applying it to everything from garments to stationery. This makes full and effective use of the advertising potential.

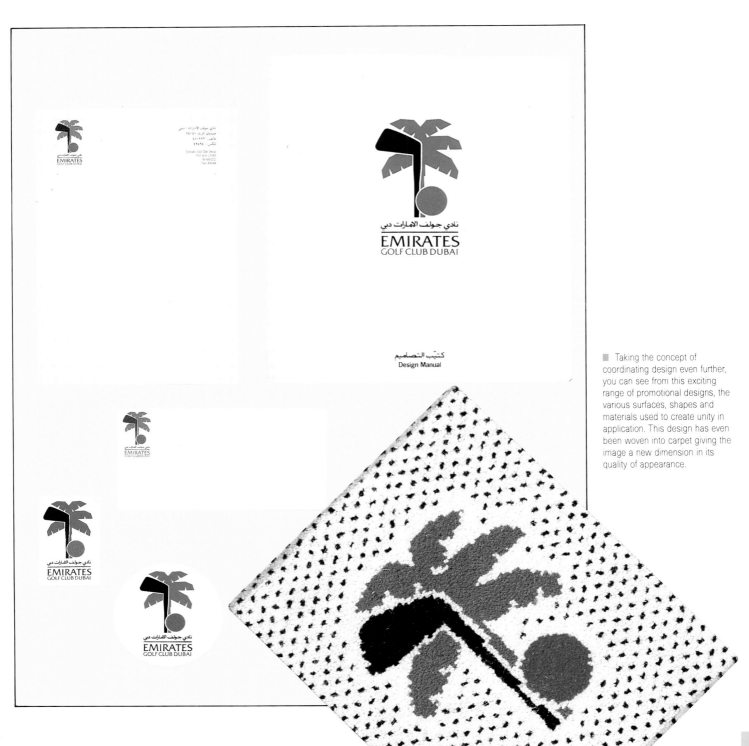

كتيّب التصاميم
Design Manual

■ Taking the concept of
coordinating design even further,
you can see from this exciting
range of promotional designs, the
various surfaces, shapes and
materials used to create unity in
application. This design has even
been woven into carpet giving the
image a new dimension in its
quality of appearance.

INDEX